Heart Exercise

Atomic to Cosmic

Jack Coleman

authorHOUSE®

AuthorHouse™
1663 Liberty Drive
Bloomington, IN 47403
www.authorhouse.com
Phone: 1 (800) 839-8640

Published by AuthorHouse 02/29/2016

ISBN: 978-1-5049-6791-4 (sc)
ISBN: 978-1-5049-6792-1 (e)

Library of Congress Control Number: 2015920460

Print information available on the last page.

This book is printed on acid-free paper.

Contents

Preface

At this point in my life, I have been going through many changes making me see things I had never imagined, opening me up to new understandings and insights inspiring this book. The title came from the major insight of the impact our hearts have on reality and living our authentic self. It is incredible the power these things have on our everyday lives at our core essence, hence the title "Heart Exercise." It can be cardiovascularly life-extending and soulfully life-changing.

A little bit about me entails a lot of counterbalancing and playing the "Devil's advocate." This is the Native American character known as the Sacred Clown, also termed a "heyoka empath." We enjoy doing things backwards, seemingly to prove a point that things do not have to be done the way the convention might have been done. My message wreaks with this flavor of energy. I love arguing for the sake of arguing, just to allow others to see something different than what they currently see. Pushing our spiritual boundaries to dive into our realities is my passion.

These concepts will stretch our boundaries of what we see in life. They can be used for daily practical applications as well as philosophical entertainment. I hope to provide tools for transitioning into a new paradigm, bringing more spiritual power and centeredness into our lives.

You will see reoccurring themes throughout this book, as some are just hard to avoid connecting, but I repeat them for their importance in life. Some are repeated in variations to show the scope and scale that can be seen, hence the subtitle of "atomic to cosmic." We all, in one way or another, understand the topics I am going to share. It is not new or radical wisdom, but I take those wisdoms and apply them to areas of life we might not otherwise have noticed.

We tend to create divisions between areas of life that have great rifts to trek. My role at this time of the journey is to see these divided areas of life on various aspects and scales of life and show those bridges revealing such interconnectedness. As we look at our human culture, there are many similarities found in the "culture" of atomic lifestyles, as well as cosmic ones. Though, we do not seem to give these scales enough inclusion by continuing to heavily focus in on our human culture spectrum.

My intention in this book is to elucidate the relationships between these atomic and cosmic scales in the Universe we live in. If we do not understand how they are just as much a part of us as we are them as living beings with feelings, then we will not know how to live more

harmoniously with them. Understanding the language of the heart allows us to speak a more Universal language. We all have a core essence where our feelings reside, but limiting our language to verbal speech facilitates a breakdown of understanding between us and beings on many other scales.

I realize I do not always go into great depths and generalize concepts, so please feel free to contact me about anything shared in this material that might not make sense or needs more clarification.

Let us exercise our hearts in seeing the unseen that is this dynamic Universe...

Our Belief

Our belief organizes many things in our lives, but what is belief and how deep can it run?

Most of the time, we have a skewed perception of what we actually live and believe. I would play sports, racquetball in particular, with such positive and fulfilling emotions. Every time I hit the ball, I thought my swing was smooth, my footwork was efficient, and my shots were strategic. When I video recorded myself, it was not as smooth, efficient, or strategic as I imagined. I could not believe my eyes. I actually thought I was better than how I actually was. I could not handle the reality of my own ability due to my own insecurities.

Other people may go the opposite direction with their perspective by believing they are worse than their actual ability. I have also lived that perspective with racquetball later on in the journey. We tell ourselves we are not as good as the actual result, probably stemming from the insecurity of worthiness. We do not feel worthy enough to be considered skillful, so we bring ourselves down to not make ourselves feel that way. This is perfectly fine and

understandable. We all do something to take us out of the reality within and "without" us. The point of all this is the dichotomy of what we believe in that moment and what actually happens.

We may like the idea of losing weight, but we might not really want to lose weight. If we wanted to lose weight, then we would. The belief to lose weight might not be as strong as we would like to think. It is like saying, "I enjoy the idea of eating healthy, but I just can't get myself to believe in it and do it."

So, what is the difference? Where does one belief come from compared to another? If we want the harshest reality of our beliefs, then we need to look at everything happening in our lives right now. These are all the things we believe no matter how much we tell ourselves otherwise in our heads. That is what we believe is possible. The ideas of possibilities are usually considered philosophy until they are put into practice and made into a reality. We all have ideas we like to live by, but how often do we live what we preach?

Speaking from our minds can create less of a heart connection, because we only listen to the communication from our heads. Our brain consciousness (known as the Third Eye) seems to put a lot of energy into our imagination, creating alternate realities such that it gets hard to come down from that stimulating high. We might not realize how much work it would take to manifest it in physical space and time.

Living these extreme philosophies can be a little bit daunting in our 3D world, but not when it is in our brains. We can daydream them all day long until we come back to reality and have to live them. In order for these philosophies to come into a more profound being, feeling and believing them in our hearts is what needs to be done.

How many of us promote intellectual consciousness? It is the ability to explain. But, is this the end all and be all? Yes, we cannot have conversations about physics with dogs, because they surely would not intellectually understand it. They do not understand English. Though, does this mean dogs are not conscious of physics and communication? Absolutely not, they have their own language and recognition of human emotions.

They understand basic emotions emanating from our faces such as smiles and frowns. And, in terms of understanding physics, dogs do. Throw a ball and watch that dog take off sprinting, jumping, and catching that ball in midair. The dog understands physics from an experiential perspective that seems challenging for even humans to perform. But, can a dog explain these things? Is intellectual consciousness the point in evolving ourselves; to be capable of simply explaining life? That is surely *an aspect* to life, which science contributes, but another aspect to it is living that kind of consciousness. A scientist can explain how a dog caught that ball, but when placed in the same position, could the scientist catch that ball? This is the difference between explaining it and being able to feel it; the athlete and commentator.

It is like reading the nutritional label of foods and seeing what to eat and what not to eat. How deep does our understanding really travel when we believe words on paper? Could we have felt the difference if the food was healthy or unhealthy for our bodies if that label was not there to tell us? The same could be said with the academia, government, and religion. They all create laws through professors, judiciaries, and gods telling us what to believe and how life should be.

We can read words and follow them on the brain level. We repeat the key words of these ideologies without really understanding them from our depths. Is this how we understand the difference between brain and heart wisdom?

Do we really "need" these texts in order to know what is right and wrong? What one person believes is right might not be what another person believes is right. That is what makes life so dynamic. All we really have is our belief of what should be done. Do we need to follow these texts to really "know" we should not intentionally do harm to someone? Yes, it does make the journey easier for a community to see eye-to-eye on morality, but if we do not feel it in our hearts, then we will always need a reminder from where we got the information; thus, being dependent on that source. Once we have felt this wisdom for ourselves in our hearts, we do not need a reminder. It is sunken in so deep, we feel it in our core, and we live it. The tree is weakest at its branches and strongest at its trunk.

Intention

Have you ever told yourself to wake up at the crack of dawn (which you rarely enjoy doing), and you actually woke up just minutes before? What was that; a coincidence? I believe it was intention. When we intend on waking up later than the crack of dawn, of course, we will sleep through the alarm clock until the time we intended on waking up.

But, how often does that happen; nearly every Monday through Friday with the aid of external influences to wake us up when someone else intended for us? We did not want to get up that early for the person that wanted us to get up at that time, and we certainly did not want to do it for ourselves. So, a third party externality is needed to help us out.

If we intend on doing something, then we do it. When the intention to wake up is strong and focused, it seems more likely to happen.

We may not understand our deeper and shallower intentions. Some intentions only go skin deep, which

means they do not have as much pull into fruition. Our deeper intentions have more pull but are harder to change once they are set. Though most of the time, these deeper intentions are ones we do not see. They do not come and go like the shallower ones do. They just are.

To show how our world works around these intentions, I will use a few examples in life showing particular intentions unknown to me at the time. They just were. In these examples, I want to point out my intention along with the outcome.

I took a licensing exam with the intention of possibly failing. What happened after the exam? I failed it. I later realized my intention was what manifested even before taking the exam. The reason why I failed was because I focused more on the repercussions of failing the exam; restrictions to retake the exam, times of future availability, and what it would take to commute to it. Most of my focus was on the contingencies of the exam.

Another exam I took, I believed I had no option to retake the test because of finances, timing, and commuting. I knew I did not want to deal with those repercussions, so my intention was to pass the test on the first try. I passed the test, all because my intention was not to fail in the first place.

I have also set the intention to not eat certain foods unsuitable for my body. Let's say I read an article talking about how harmful a food is to the human body, but I

continue to desire the flavor. So, I set the intention this food is no longer good for my stomach and intestines, but my mouth did not quite get the same message.

Setting this intention creates for a disastrous experience, because my stomach and intestines felt the intentional adjustment that this food no longer serves a healthy purpose, but my mouth received a different message. I ended up eating the food for my mouth and not for my stomach. What happened? I had initial enjoyment followed subsequent bowel issues by setting two conflicting intentions to two different parts of my body for that one particular food.

There are many other intentions in life that manifest in reality, and I would like to mention a few others I believe we generally go through. We might not see them as being our own creation. Though, we have unconsciously set the intention.

Another aspect of intention pertains to the type of relationship being established during the relationship. Let's say a police officer exercising his rights to excessively enforce the law in encounters a citizen exercising their rights to excessively resist the law. One is trying to protect the community's freedom by pushing the limits of his force, while the other is trying to protect their individual freedom by pushing the limits of his freedom. So, they meet because the citizen is walking around the town with a legal firearm. He is not breaking the law since it is a registered weapon, and the constitution allows him to do

so. But, the officer feels the excessive need to harass this person since he does not initially understand the citizen's intentions.

The officer feels threatened by excessive exposure of a legal weapon, and the citizen feels threatened by excessive force of the law. They are both using and conversely asking for excessive force in either direction simply because their intention is to show how powerful they both can be since they feel like the other is taking away their power.

This relationship is already starting off rocky by how they are going about their intentions. Some people might ask the police officer, "Why do you need to unreasonably enforce your law?" And, other people might ask the citizen, "Why do you need to unreasonably enforce your freedom?" If one is perceivably unreasonable, then the other must be equally unreasonable to balance it out.

Interestingly enough, both are using the same system to fight each other. It is like trying to buy money with money. At some point, the bubble has to burst. That is the kind of relationship they wish to establish in order to let the other know their feelings about the situation.

I personally do not refuse to show officers my license and registration just to prove it is our freedom to refuse. Does this mean I cannot talk to the officer about the issue, though? We all pick and choose our battles and how we go about them.

The point is to show how our intentions really set the stage to the experiences we go through. Being in touch with the other's perspective helps establish a more understanding relationship without building extreme controversy and misunderstanding.

Recently, I went through a phase of unemployment because of life changes. I was looking for jobs in a new field I had very little professional experience. Yet, I was sending out applications and resumes to organizations I found. After reading through their websites, there were some I really connected with and others were "just applications to fill out." What would you suppose was the outcome of who called me back and who did not? The few organizations I connected with were the ones who called me back within a couple days. The others never responded.

Why was that? That feeling of connectedness was the energy I sent out to that city. I was more willing to spend my time working for those organizations rather than the others. The people who felt it were the ones who called me back.

It comes down to the energy we are sending out to the Universe to hear. What if someone did not get any calls within a week or two of sending out resumes and applications? Was that the threshold of hope, and anything beyond those two weeks was despairing? Feeling hopeless like we are not good enough to work for others can be the feeling that other hiring managers sense. They would not want to hire an unmotivated hopeless. They

probably want a motivated hopeful, and this unhopeful signal continues broadcasting to every person listening. Then, it creates a longer period of unemployment and the *dark ages* until an internal change occurs. There has to be a different signal saying, "I'm hopeful, now. I feel worthy in what I can contribute to the world." We have to be willing to change our feelings within ourselves in order to change our relationships and our reality.

Have you ever heard of a guy or girl looking for a relationship, but they are having a hard time finding someone? Desperately looking for a partner created very little success. Though, once they engaged in a relationship, they seemed to have such an easy time meeting people. Why is that? The whole time, they were frustrated not being able to find a partner to be with. They questioned their value and worth for any prospect.

Something changed within them. They decided to talk to someone since they felt confident in who they were, and the relationship began. After being in the relationship, they could not seem to stop bumping into other people they previously dreamed they had met a few weeks before. What a conundrum, right? The conundrum pertains to intentions. Their original intention was, "I'm not good enough for anyone because I haven't met anyone." Other people sense this intention, with or without being conscious of it, and choose not to engage. "I don't want to be with someone who is that broken," could be the feeling; thus, people keep their distance.

Once this person felt whole and established a relationship, the feeling of worthiness was lifted. The intention changed to, "I feel whole, and I now have something to share!" More people started feeling this intention and wanted to engage.

In setting an unconscious intention, we simply feel like it is the only option. Looking back at my tests, I was not consciously setting those intentions to fail or not fail. It was the *only* intention I could see at the time, so there was less of a perceivable choice.

During the moment, it was hard for me to see outside of the intention I was setting, mainly because I had such tunnel vision of that intention, "There's no way I could possibly pass this test." I truly set that intention because I felt the goal was impossible, so the exam was impossible.

How do we go about consciously setting intentions? We all create intentions and feelings about life in every single moment. It is how life comes into being. Setting the intention (or creation) is different for each person.

From what I have been noticing, we all have our own particular "sigils" in order for us to feel like the intention has been officially set. Writing it on a piece of paper, sending an email, having an audible mantra, or quietly meditating on it seem to be common ways we feel like our intentions and goals were set. But, without using these preferred mediums, the intention does not quite feel "real," and it will not come into being. It just sits there

in the Ether until we use the medium and ritual we feel actually means something.

From my experience, people told me to write down what I want to do in life, and it will happen. I tried it, but that did not give me the feeling of accountability. It was just a piece of paper with some ink on it. It holds no real energetic value to me. Although, vocally telling other people my intentions holds more value, and I feel accountable. That is one medium I find valuable in bringing something into being.

Another way for me to manifest intentions is by using technology. For some reason, I put more spiritual weight on electronics than paper because of its recyclability, and more things seem to manifest for me at the moment when it is done through technology. Sometimes, I want to mediate a frustration when someone said something personally offensive about life. They did not directly say it to me, but what they said offended me. I had to send them a message using the internet. Even though I did not get a direct response, it felt better and official (because, I got it off my chest and out of my head).

Setting that intention creates the bond with whatever we are trying to connect with; buying a house, joining a band, living with someone, and so on. Realizing our mediums in creating an intentional bond is crucial. Without the bond, there is very little holding the intention between us and what we are trying to connect with. In buying a house, people seem to hold dearly onto the spiritual bond

of writing our names down on a piece of paper. When we sign our names, "it's official." There is no getting out of this bond, when in reality, it is just some scribbles with black dye on shaved wood. Yet, there can be so much power in those scribbles.

The same goes with shaking someone's hand. When joining a band, all it takes is a handshake with the band leader, and there is a strong bond saying, "I'm here to play with you." People really respect handshakes, because it is personal contact that can say something about someone's character. Breaking that handshake and bond might be very disrespectful.

Marriages between two people who deeply love each other create unifying bonds through wedding rings (and other mediums such as wedding vows). It might not feel certified until there is a ring on the finger. When that ring is taken off for personal reasons such as discomfort, exercise, or cleaning, some of us can feel offended. There is a lot of spiritual weight put on that medium, because without that ring, the connection does not mean as much to them.

Do these trinkets and rituals truly make something official? Of course, since it is what we all do during these moments. There is a reason why we do them. It is that intimacy and proof we are looking for in ourselves and others. In apologizing, we want to show the other we really mean, "I love you," or "I'm sorry," by giving them something that

has meaning to the other. Chocolates, flowers, or a date night might show effort and consideration for the other.

This is more of physical proof to the other, but does it end at physical mediums? Undoubtedly, I am going to take it into the metaphysical. What if these physical things were not as available? What if the thing we felt made the bond official was not so tangible? Does that mean there could not be a purchase of the house, playing in the band, or marrying our partner? I am certain that is not the case. There is a heart connection that says, "I will," no matter if a paper was signed, a hand was shaken, or a ring was given. It is more of a feeling like, "I'm there no matter what." We have all felt where the sentiment was so strong, it did not quite matter what things were surrounding it. The pursuit was always there.

It might be harder to create our intentions when we have conflicting energies in them, though. We can say one thing but with a different intention causing a dissonant energy in the communication. We hear one form of intention through words, yet we felt a different one from the heart.

For example, someone could give a smile saying, "That was wonderful," when they are really feeling like it was awful. Another example would be a woman asking her partner where they want to go to for a night out on the town because the choice is up to him. Though, her intention was really for her partner to guess where she wants to go, making it seem like she was giving him the free will to choose. It can be a skewed form of communication,

because she gave him free will hoping he would pick where she wants to go without verbally saying it.

Again, this creates two different energies at one time; the energy from her words and the energy from her heart. How can we create more of an alignment with our words and our feelings? We can try to be more transparent in our intentions with our verbalizations, which opens more space and understanding in each other's feelings.

We look at alignment as resonance or being in sync with something. When we do not align with something, there seems to be dissonance and awkwardness in the experience. But, what does it do in our lives?

Being in line with something allows us to flow in a smoother direction without as many bumps and redirects. Some could say this alignment is focus and attention span, while others could say it is connecting with our divine plan. Maybe, it is a little bit of both.

What if we do not feel like we are a fit for working that corporate position, or that company does not feel like we are a fit for them? There is not an alignment from either direction of this intention. Believing we are a fit for that corporate position and the company feeling the same way is an alignment with the manifestation of that reality. Both sides of this relationship aligned with each other.

The same concept can work with finding a relationship with a life partner, where we align ourselves with our desires in life.

Truly connecting with others in life, from my experience, has been done by feeling the notion that it is about what I want. And, it is also not about what I want. It is about what *we* want. This creates a better understanding of what we would like within each other rather than what we would like solely from the other.

Another aspect to alignment is what we are willing to go through in the relationship. When what we want is not aligned with what we want to deal with (externalities), we create stress and fear. Being afraid of externalities causes a division between our will and the externalities leading to declining self-confidence. When our will is aligned with what we want to deal with, there is an understanding between all aspects. We need to be willing to deal with our situations and decisions. At the moment that is understood, self-confidence, friendships, and the right partner come into alignment.

Let's use dating as an example. Yes, I have used this example too much. But, we may feel like our current residential, financial, and emotional self is not worth someone else's time. Or, they may feel the same way about us. Someone might think, "I'd have to do all of these things to connect with this person? That's so much work!" The right one for us will align with our situation where we

do not have to try to be someone else for them. We can be us in the moment, just as they can be them.

If we need to be someone else in order for the interaction and relationship to come into being, then the future of the relationship will continue to be difficult trying to maintain being someone else.

Relationships last because of alignment. Maintaining and nourishing what the connection between the two is built on is what keeps it from breaking. There could be an alignment of career goals and within the same understood timeframe as each other. So, the relationship continues as long as there is a common understanding of the connection between the two.

However, it will break once that intention of the career shifts within one person and not the other. Disharmony follows as the shift rocks the foundation of the relationship, and the two have to deal with the changing energy between them.

Looking at how many aspects in our lives we could be in alignment with, what is our daily activity like?

Being in line with what we feel like we need is realizing how much is too little or too much for us in the moment. Where is that point where we are balanced as such?

Ironically, we need to feel the imbalance to understand what is too little or too much. It is inevitable to always

feel that balance perfectly. We need to try eating a little and a lot in order to understand what feels right and in alignment with ourselves.

So, do we need to beat ourselves up for not getting enough or getting too much of anything? No, we are simply searching and experiencing to find that alignment. We just have to experience our intentions through each moment, bringing different states of consciousness to our lives.

The Ego We Hate to Admit

"It is unimaginable, inconceivable, and just plain absurd!"

These words can be a great tool in realizing our egos. How often do we observe and experience something in life and tell ourselves, "That's absurd!"

The biggest form of ego is believing there is no such thing as ego. I am sorry to ruin whatever perception there is about ego, but ego is in everything. There is no such thing as non-ego that resides in duality, energy, and reality. From the scientific notion, there is no such thing as empty space. In empty space, nothing could exist, so if we experience "empty space" in one way or another, then it is not empty. Looking at ego through this light, there is not a right or wrong ego. It is like positive and negative ends of one single waveform. In order to have an up, there needs to be a down. So, we cannot have positivity without negativity.

Something most of us seem to do is claim one behavior in life to be egoic, but another behavior is not. Notice that most of the time, the egoic behavior is one we do not want

in life, but the non-egoic behavior is one we want. "You're so dense, hard-headed, and stubborn!" We feel like this is someone's ego, simply because we want them to be light, open-minded, and malleable. Though, notice how being dense, hard-headed, and stubborn are the characteristics of a diamond, and we surely enjoy diamonds. Isn't that interesting? People may say selfishness is egoic, but selflessness is not. Darkness is egoic, but light is not. Black is, but white is not. Negativity is, and positivity is not. Sadness is, and happiness is not. Evil is, and love is not.

To clear things up, we can simply say both are egoic from their own perspectives. Sure, if we have been feeling more negative for long enough, we will tell ourselves we do not want to feel this way and turn toward the other side of positivity believing it is *the* point in life. "Positivity is all there is!" The same can be said about positivity. Eventually, it turns to negativity after realizing life is not always so glamorous. I have met people who intentionally turned negative because of their insight into the "downfalls" of too much positivity.

We all have our favoritisms in life at this very moment, where some behaviors feel good and bad to live. There is nothing wrong with this, "Everyone's doing it." Not to put peer pressure on anyone, but we pick a direction in life, and live it to whatever intensity we feel necessary. It is not egoic to be single or in a committed relationship. They both have ego. Single people feel that committed people are wasting their time, and committed people feel

that single people are doing the same, "Awe, you haven't found a partner, yet? Don't worry, it will come." They have not found a partner because they do not want one at this time in their life. The single person is saying, "Geez, why have you been in your relationship for so long?" But, it is perfectly fine to be in either state. We have been both at one point in our lives, and there is no absolute set time to be in one or not.

Realizing ego is simply whatever we feel we need to do in every single moment shows there is no escaping ego. Saying it is "this" and not "that" is still living in discrimination and division. See, I am showing my ego by clearly favoring unity than division at the moment, and it is because I feel we have lived far too long with this level of discrimination and division such that I am promoting unity. I feel the need to show the unity in what we have divided; thus, that particular ego is coming out. Division has its righteous place in this Universe. Without it, there would be no individuality or borders dividing my sense of home from your sense of home. No worries, because worrying is egoic, right? Just kidding! In order to understand not worrying, we need to first understand what worrying feels like. This is the duality that is positive and negative ego.

We can see these sorts of egos within people and even some animals. But, where does this insight end? Where can we no longer see and feel into the egos of other beings

in this Universe? Does ego only reside in humans and some intelligent animals?

If all matter is physical, energetic, and consciousness at one level or another, then everything must come from a greater depth of ourselves that we do or do not see. Just take a look around and peer into that person walking down the street. What do you see *within* that person? What sort of soul connection are you getting by observing them? This is peering into the invisible.

The hard part is seeing and feeling this in everything else around us. How do we view everything as objects but also with personality? Notice the battle between viewing life in terms of objects or people? Objects have "no life," while people have a deeper personality and individual being to be sought after. It seems the battle between what is an inanimate object and what is alive can be viewed as one in the same. Every object is made of the same thing as any human being; energy. Any personality and soul life force seems to be within humans, which are made of energy, so objects made of energy also have this same life force.

If ego is favoritism, and favoritism is duality, and duality is energy, and energy is the life we experience, then energy is ego and everything in the Universe has ego. Even the tree that has been right outside the window has an ego. Some go toward the sunlight and others might want to hide from it. Some trees wrap themselves around a neighboring branch, while others lean away. This is a perfect example of duality.

If you would like a more visual understanding of ego and its result as energy, let's look at a wave function. Things start out as "nothingness" where there is just a flat line. There is no activity, and there is no difference in egoic opinion.

But, what happens when something favors one particular direction on this line?

It gets pushed down toward one direction. As with everything in this Universe, it needs to have a polar opposite. So, a favoritism in the other directions is created.

This is just a 2D depiction of a wave function. We typically illustrate energy as oscillation, fluctuation, and vibration, but seeing it from 3D, it looks a little different (like a spring). For the point of showing polarized egos, we will keep it in 2D.

For every down, there must be an up. This is what happens with any favoritism in life. When we push in one direction, let's say toward the side of white, we create an imbalance in the opposite direction, being black.

To expand seeing this egoic spectrum, just imagine the absolute worst and best things in life. What would experiencing those two things feel like? This spectrum is that particular duality's boundaries.

Let's say the duality is friendship and betrayal, cheerfulness and depression, or nourishment and execution to whatever intensity we wish to stretch it. Understanding how far these things can reach within a human being on the planet is what allows us to understand them at those intensities. This is a very important aspect of ego, duality, and energy. With really extreme ego, the energetic wave gets stretch to great distances. As the duality and dynamic difference is more understood, the wave is not so stretched creating a higher frequency of energy and brighter light (if that is what we want).

There are a few spiritual beliefs floating around that need to be acknowledged as egoic. We cannot follow the common spiritual belief of being *only* accepting and passive of other beliefs. That leaves us as slaves to everything around us, because we have to agree that others can do what they want, while we sit back and accept it. We also might follow the spiritual belief that everything can be ours if we believe we deserve it. That leaves us believing it is alright to do whatever is necessary to get it our way, as we

are on track to be the ruler of everything we see. Both are necessary in this Universe, but if not balanced with their opposites, they can lead us down a particularly intense pathway. We all favor egos at some point in our lives (daily, weekly, or even yearly), and at different intensities (miniscule, moderate, or intense).

One day, I chose to be controlling. Another day, I chose to be passive. Being conscious of my ego and its effects on myself and others is the only thing I believe I can do with ego. When I believed life was more about me (than others), I had no idea the effect I was inflicting on others involved in my life. Once I went the other direction and paid more attention to those around me, that ego of noticing others lit up in my face. Contrarily, I did not give myself as much attention, so I went back to selfishness, then back to selflessness, then selfishness, and so on. This is the wiggle we try to balance. Sometimes, it wiggles and favors one ego so much, it becomes extremely difficult to counterbalance and leads to some disastrous lifestyles.

Though, we usually do not see these imbalances because of how much we have stretched our egos. Picture someone who has to work all day and all night. I bet someone who wants to enjoy a night out with friends might not understand how someone could "waste" their time working so much. I would also bet that worker-bee would not understand how someone could "waste" their time going out with friends all the time. This stretched dynamic is what happens when we intensely favor one ego much

more than the other. We lose sight of understanding what the opposite ego looks and feels like. We now have egoic blinders on. My ego can only see what my ego favors and however much my ego attaches itself to this perception, which results in the difficulty understanding the opposite ego I am misunderstanding.

In these states of misunderstanding, there are a few symptoms to take note. Anger is a clear symptom of ego. When was the last time we were angry or frustrated with someone or something? Did you ask yourself why? I would bet it was because you did not get what you wanted in the moment. Something happened, and it was not what you wanted, so you became angry. Even if what you wanted was for someone else, it was still something you personally wanted. This energy for not getting what you want is the negative charge of ego.

What is another symptom of ego; joy? When was the last time we were joyful? What happened? Did we experience something in life we favored and preferred? We got what we wanted. This is the positive charge of ego.

A way to see our favoritisms and egos is by seeing our slander and compliments. An example I would like to shed light on is a philosophy discussing weirdness and rebellion. For those who want to live against the mold of society, it would be a compliment to be called weird or a rebel, however calling them normal and a conformist would certainly be considered slander. On the other hand, to those who want to be more normal and conforming,

it would be slander to call them weird or rebellious. So, when we see particular people in life who claim it is a compliment to be called weird (because it shows creativity and uniqueness), they are simply saying, "My ego favors the weird side of the normal/abnormal duality." This does not mean we *all* need to enjoy being called weird. And, it also does not mean we *all* need to enjoy being called normal, either. When we get caught up in the offensiveness of these compliments and slander, we are still working through those levels of duality.

Seeing the normal and abnormal duality from a larger perspective, there is not such a need to feel offended as we understand what is at play between the two. These compliments and offenses can help us understand our egos and who we are on such a greater level. Our ability to work with and understand other egos is determined by this skill. Without seeing and feeling different types of egos in the world, we live in a smaller box where anything outside of it seems "absurd."

We do not need to feel bad about admitting our ego. Just like any addict, the first step is admitting to the addiction. We are too afraid to admit what we are doing is coming from a place of ego, even positivity. Just remember, "I want…" is our ego. "I want this to happen in life." Conversely, "I don't want this to happen," is us still wanting something but from the negative aspect. "I want this for another," is still egoic even though it is a desire for someone else's gain.

The Energy Between Us

Energy is something we all seem to have some sort of perception about. Some of us feel like energy is bright light we see coming from flashlights or heat coming from the oven. But, just as any definition, it has conditions and boundaries. These boundaries create bubbles we live in, being that we cannot see outside of our bubbles. Most of our bubbles, boundaries, and definitions set the stage for how we can live; what we can and cannot do. The question is, "How do we pop these bubbles?"

How many of us define energy as being "this" and not "that?" How can we pop that bubble and realize that energy is everything; energy is the Universe? Energy is not bound *only* to the lights coming from our electronics or the heat coming from our stoves. It is also scents coming from flowers, sounds from our voices, tornados spinning around, the Earth's orbit, and the very rays coming from our Sun. Energy comes in all shapes, sizes, and dimensions. The tough part about these definitions of energy is we tend to miss out on how many ways we can see these variations and dimensions of energy.

It is a very simple thing. Energy is the most basic aspect of this Universe. Just like an intimate dance, it takes two to tango. There is the positive and negative aspect, a masculine and a feminine aspect. Both need each other in order to survive and dance. They hold hands and swirl around each other just like the Sun and the Earth. With only one aspect without the other, there is only a single dot left alone not connecting the circuit.

The cycle breaks. In order for energy to be in a state of cyclical existence, it needs to have polarity; positive *and* negative, as I have already mentioned plenty before. This same thing happens everywhere in life. No matter how alone we may feel, we are not. There is always something else pushing or pulling on another.

We are made of stardust; meaning, the atoms in our bodies came from the very stars we look up to each night. They once exploded shooting these tiny balls of energy through space and time, which eventually attracted to other tiny balls. After enough matter coalesced, they built a very dense and hot core; the Sun. The remnants floating around the newly formed Sun created belts of stardust, which formed into solid Terrestrial planets. The remnants of that created the gaseous Jovian planets. On one of those Terrestrial planets, formed simple beings as bacteria, and eventually evolved into larger beings called humans. And, the chain gets larger or smaller. You pick the direction. As the spiritual philosophy goes, "As above, so below."

A component of frequency is simply oscillation; just like in the oscillation of the Earth orbiting around the Sun. One year can be looked at as one oscillation. That oscillation (or orbit) can be broken down into 12 months, 52 weeks, 365 days, 8760 hours, and 525600 seconds. All of these (dimensions) equal one oscillation around the Sun. The reason why they seem different is because of how these dimensions are broken down. Atoms follow this same construct, as they are miniature solar systems. Sub-atomic particles orbit around the nucleus at a particular rate, producing a frequency.

If we can find a frequency and energy in astronomic and sub-atomic orbits, then we can break some boundaries and find it within people. For example, how often does your friend seem to visit? Is it once a year? What about every month? How about every day? Does each frequency give you a particular sense of the energy within the friendship? How close or intimate is the relationship when you only get in contact with someone once a year? It can be intimate during that visit, but what is the energy like between two friends that see each other every day? It is like a marriage!

There is a very close union between any two things that see each other every day. Whether it be between two people, a dog and a cat, or even a musician and their instrument. When I play my guitar once every few months, the energy between us is not nearly as strong as it was when I played

every single day and for hours each of those days. This is connectivity. This is frequency. This is energy.

My point with this is to show how energy is not something we can only see with our eyes or smell with our noses. It is something that can be felt with a hug when a friend comes home or when a stranger smiles at us. It is a feeling resonating throughout our bodies when we give someone a meal or enjoy a sunset with them. Have we ever asked ourselves why that is? Most biologists will say, "It is just chemicals releasing from our glands." But, is it *only* that? What is telling our glands to release these chemicals that give us these feelings of good or bad, love or hate, and happy or sad?

Understanding that people being around or not around other people as energy can break the previous boundaries we set for ourselves. Just picture how many ways we can see and especially feel this fluctuation and dynamic that is the Universe! Who knows where it ends? No one does, because then there would not be anything to do here within this energetic Universe…

Energy is communication. There is communication throughout the entire life process. First, parents communicate they want to bring another human into this reality. After that, the baby lets mommy know they are alive by communicating symptoms of morning sickness, heightened hunger, and kicking. After birth, the baby develops a different form of communication; crying, walking, and facial expressions. Is this the only

form of communication? Are intuition and *invisible* energy included in this communication? Does a mother intuitively have a connection with their children just as one twin can sense the other twin? Get in touch with this language, and we can understand how to speak it with not only humans, but even down to atoms!

In order to understand how energy can work in an invisible and human spectrum, we need to break some barriers to things that can feel. Everything has feelings, consciousness, and soul.

Environmentalists and vegetarians seem to hold particular philosophies against cruelty toward plants and animals. Environmentalists look to preserve and connect with trees, because they are an important aspect to life on this planet. This is absolutely agreeable from my end, because without them, we would not have natural oxygen. It would be an excessive and unreasonable act to Mother Earth to take them away. We all seem to work with them in one way or another, as they are working with us as well.

To vegetarians, the treatment of chickens, cows, and pigs are too harsh to justify eating them. Vegetarians mostly do not eat meat, but eating fruits, vegetables, and grains are perfectly acceptable. There is no remorse in eating the meat of plant beings compared to eating the meat of animal beings.

What is the difference? Consciousness seems to be the most prevalent root to this frustration. We tend to favor

those who reflect some sort of human consciousness. When we do not see something as being conscious, we do not "feel" for them. People who can slaughter other beings of this Earth; animals, trees, and even humans, do not see life with this commonality of consciousness. They are viewed as objects more than anything. A strawberry is an "object" to be eaten by people. But, chickens are "people" to not be eaten by people. There is a discrimination at play.

Though, chickens seem to emulate more consciousness than strawberries, because it can move faster and make quicker decisions. We can see the human feelings in chickens as they scream and flail when we grab their necks. If we grab the neck of a strawberry (the stem), there is not the same sort of noticeable reaction by the strawberry. Does this mean it does not feel?

Everything feels! Even a strawberry feels when we squeeze it too hard. It bruises just like the chicken's neck. When touched, ferns can contract their leaves in less than a second! All life feels. We just do not seem to be as in touch with their feelings for us to actually be aware of them. With this particular realization, it is hard to say we cannot eat chickens but we can eat strawberries. They are both slaughtered for our own preferred nutrition. A machine or human slices the necks of chickens just as a tractor or human pick the necks of strawberries. Both are treated the same way, but our consciousness only feels for one and not the other.

When we approach someone with a particular feeling, whether it be one of acceptance, curiosity, sadness, or fear, the relationship will be like that. They will feel the energy we bring each time we see them just as we will feel the energy they bring.

Let's ask ourselves, "What is the feeling we have when walking down the street?" Is it, "Step off, you're in my way," or is it, "Hey, how're you doing?" Most of the time, we do not really know until later in life when we reflected back on the interaction. It is usually when we say to ourselves, "Wow, I didn't realize I felt that way at that time." But, during the time of the experience, we only knew what we felt. So, there was no other feeling to be projected and exchanged.

If we have the "step off" feeling on a regular basis, what is our daily life going to be like? Most people would agree *only* having the step off attitude can be very limiting to our relationships, because there are so many other energies to approach people with.

For example, I walked by a group of geese resting out by the pond. The first feeling they showed me was yelling, letting me know me to watch myself because they were unsure of me. Once I realized my energetic aura about me, which was, "I do not need to justify myself in walking down the street, because it's a human's street," I looked them in the eyes, came from my heart, and changed it to, "I am sorry, and I respect you were here first. This is everyone's street. I am walking to get to somewhere else."

No more than two seconds later, they stopped yelling and went back to resting.

What is it like when we feel negatively toward a friend? Are there a lot of fights and tension? How does the other handle the negativity? All of this is because of how we feel about the other in the relationship. Now, what is it like when we view technology with the same energy? Does it break faster than it "should?" Does it glitch unlike a new version ought to? Why is this? From my experience, when I loved the technology I was in a relationship with, it never crapped out on me like it would for others. But, I might have appreciated it, took care of it, and sent it that energy differently. Others might have taken it for granted and became frustrated when the slightest hiccup occurred, grudgingly felt like they would need to buy another one. When I felt this way with my technology, it depreciated much sooner.

Can we see the same with our bodies? How often do we approach our bodies with this same sort of frustration? Some examples are, "My eyes are too droopy. My butt is too flabby. My shoulders aren't big enough. My hair isn't the right color. My abs aren't showing. My skin sweats too much. My face has gross pimples. My freckles are ugly." How often do we cut our bodies down? Do we ever wonder if our bodies feel this energy from us just like our friends and technology can feel?

Just as our friends would not appreciate such feelings toward them, our bodies have feelings that need to

be respected, too. If we do not believe it, then we are neglecting that just as someone who believes animals do not have feelings, where they believe anything can be said or done to them without them feeling anything.

Our bodies talk back to us all of the time. When we stretch too far, our muscles say, "Stop!" When we eat perceivably poisonous food, our stomachs shove it right back out. When we feel nervous, our skin sweats and blushes. We are in relation with our bodies as we are with our friends. But, the communication is not with words out of our mouths, it is with the feelings in our hearts.

What is it like when our skin gets pulled so much it cannot be pulled anymore? This is the threshold within the bond and relationship between those particular "people," where they feel like they cannot take such a separation. It can be painful to have the skin actually ripped apart beyond the bond between skin cells. We are simply feeling the effects of this relationship between our skin cells not wanting to be pulled and separated at that intensity. We do not like that feeling, and we label this as physical pain.

This separation is just what humans feel when a third party tries to pull two people apart. They do not want to be separated, but that third party is imposing its forceful will onto the relationship. Picture any time in history when this happened to us or others. What was the feeling? We usually felt some sort of pain. At a human level, it takes much longer to feel the effects of two humans being separated for a longer period of time. We need to be taken

thousands of miles away and over a longer period of time for us to feel this kind of pain.

But, let us look at the skin cell's perspective; skin cells traveling just a few millimeters in milliseconds on a cellular level could parallel what humans feel over thousands of miles from a human's perspective.

This sort of communication does not start or finish with technology, fruits, geese, humans, and so on. I have consciously and intentionally done this with various insects, mammals, and humans on daily experiences. The more we get in touch with our feelings during everyday interactions, the faster we can recognize them in the moment and call on them more willingly.

My hope was to shed a little light on the energy and communication in life. By showing various forms and dimensions of energies, it is more evident how embedded energy is in this Universe. It is everywhere, and it is spoken in many forms.

Self-Medication

As a common theme running through the veins of this book, our belief is a manifestation of our reality. So, if we believe something will heal us, for whatever reason we believe in it, then it will heal us. But, what separates us from being able to heal ourselves or rely on medication to do it for us?

What is medication? Why do we medicate? Is it ok to medicate? These are big questions within the aspect of health. Everything we put our wellbeing into can be viewed as medication. We all believe something in this Universe will make us feel better, and feeling better is health. If a frightened child feels worse without holding a teddy bear, then they will feel better holding one. If a person feels worse without a friend, then they will feel better with one. Though, it is hard to include people in medication, because we tend to look at medications as necessities but friendships as wishes. It seems like necessities and desires are one in the same, just at different intensities.

When we "need" something, we simply want it more than anything else at the moment. When we "want" something,

we could go without it a little longer than other things in life. For example, we "need" food, but "want" friends. This is a common perception in the human perspective, but after a certain period of time without either, we tend to feel the same way for both.

What is it like when we do not get the amount and quality of food we prefer? Do we get cranky, groggy, less motivated? What is it like when we do not get to spend time with our best friend? Do we get cranky, groggy, and less motivated? What is it like when we do get the food we want? Is there more peace, presence, and motivation? What is it like when we get to spend time with our best friend? Is the trend more evident?

Is there not the same effect no matter what aspect we are looking at? All it comes down to is what we do and do not want; what we feel will and will not help us. That is medication. We are all different and in need of different things at different times in our lives. So, it is hard to say, "Medicating ourselves is a bad thing," because we all medicate in one way or another. The difference comes when looking at how and why we medicate ourselves.

To start, we need to see where chronic illness comes from. From my experience, we become injured or ill because we expose ourselves to something over and over again without realizing the effects until they hit us. Let's say our knees hurt too much. Have we wondered why? Maybe, we ran on our knees harder than they preferred. Our knees are now communicating, "Enough! I'm done with this,

so either change the way you run, or do something else!" How often does this happen where we do not feel the symptoms until we cannot even walk?

There is a threshold within all of us until we snap out of the trance of oblivion. We cannot ignore what we are doing to ourselves forever. This is usually why we tend to need harsher forms of medication. We are not being aware enough of our bodies and environments, and the symptoms cycle around.

Eating unhealthy food is one simple example of this cycle. We could eat harmful foods, creating restricted movement within our bodies. This, in turn, creates lower levels of activity, which also does not allow for exercising it out of the system. If we are not aware of this cycle as much as we could be, then it will keep building up like a landfill until there is no more land to fill. Then, what happens? We become injured to the point where we need a third party intervention; medication.

The placebo effect stems from a belief somewhere deep within us. A doctor gives someone a sugar pill for their illness and tells them it will fix them. This is our belief and power given to others. Not only do we believe the pill will fix us, we believe the doctor's word is true enough such that the pill will fix us. If that pill was given by a stranger, it might not have had the same healing effect.

This is our belief the prescribed pill could heal us even though it contained the same composition as candy. Notice

how the only thing that changed was our unknowing and knowing. That is what determined our state of being.

A personal example includes being chilly. As soon as I grabbed the remote to turn on the fire, my frigidness went away even though the fire was not on and no heat had gotten to my body. Did my temperature change because I knew I was about to get something I believed I needed to heat me up? When, the reality of the experience was, I felt warmer just by believing I was about to be warmer.

Have you ever seen someone learn their sandwich had a thousand calories in it? What was their feeling about it? "Why'd you tell me that? Now, I feel worse about eating it!" What actually changed? The calories did not really change, so it had to be their perception of what they just ate that dictated the impact of it. This is the placebo effect, which appears to be based on our belief and perception of the world.

What that perception is based on is up to us, though. It is our choice to feel like something is gross, dirty, threatening, and harmful. A runny nose does not have to negatively affect us unless we choose to feel like it will. A punch will not hurt us the same if we do not view it like it is harmful. Professional boxers do not see a punch as knocking them out, which is why they can withstand so many punches. It is a necessary part of the art and practice. We, on the other hand, feel like a punch is very harmful. So, we can barely take one punch until we pass out. And conversely, it is also our choice to feel

like something is pleasant, clean, inviting, and helpful. Whatever we gravitate toward is what we feel will help us based on our choice.

We do not always understand what we believe in the moment of living it, because we would have an all-knowingness about our infinite souls (which might feel kind of boring after a while, since the mystery is gone). That is the interesting part about life; we live what we believe, but we do not understand what we believe until we live it.

This placebo effect runs much deeper into our ability than a sugar pill curing headaches and minor pains. Studies have shown that people have been known to cure cancer by this same belief! That is an incredible amount of power considering how powerful cancer can be. But, where is the difference? Why don't we always believe that can happen?

Most people would agree losing a single pound of fat is possible when someone weighs 300 pounds no matter the genetic handicap claimed by scientists. But, when trying to lose 100 of those 300 pounds, "it just is not in the genes" to make it possible. Why is that? Why can that person lose 1 pound but not 100? It is not entirely up to the genes. It is up to the person believing there is a cap to what is achievable and necessary. It takes a change in exercise, diet, lifestyle, but mainly seeing a purpose in their health. Exercise is not only an act of going through detrimental pain by regularly breaking our bodies. There is another side to it that is missed; the gained strength after the recovery. There might

be too much focus on one side of the experience rather than the other. It is like an apocalypse. We tend to look at the experience as death, destruction, and the end, but it is actually the death of something old and the birth of something new. We just focused too heavily on the death of the old to really notice the birth of something new.

With this realization of having more ability in our health than we may believe, where is the limitation? Most of us understand we can recover and heal ourselves in certain ways but not others. We can break our muscles down during exercise but will eventually recover and grow even larger. If we cut our skin, the skin will eventually pull themselves together to heal in a stronger callous. If we break our bones, the broken area recovers and heals even thicker than before. How interesting? Essentially, "no pain, no gain." If we do not use it, we lose it. Weakness is what ensues after prolonged periods of stagnation.

Depending on our ailment, our medication changes. If we have an ailment that came and hurt us so quickly that we did not see it until it ripped our insides apart, then we never really understood our threshold the entire time until "it hurt more than we could handle." So, in order for this pain to change, we need something to come in just as fast to solve the issue until "it feels better."

For instance, if we break our leg, the act itself may have taken no more than a split second. We may need a remedy that puts it back in place; surgery, some metal plates, and a cast.

However, a slow injury may need a slow remedy. This is our issue with medication. We seem to create lasting injuries, through overuse, diets, and especially stress that creep up on us biting us in the ass when we are older. These ailments, whether it is a loss in knee cartilage or a loss in self-purpose, had years to build into what they are. To organically fix them, we need to organically reverse the process. Whatever we spiritually did to get there needs to be worked on rather than avoided. If we take short-term medications (drugs) to try and solve a long-term problem, then we are setting ourselves up for a longer battle.

The hardest part about this is seeing how physically and "metaphysically" our illness is rooted. A broken bone is clearly rooted in our physical activity. We jump out of a tree from too high and our bone breaks. But, it is metaphysically rooted in the spiritual longing to feel the sense of flight from that height.

Headaches are rooted in the physical activity of dehydration, climate change, or sensory over-stimulation. There was a need to feel something in particular that generated a physical pain in our brains. It is metaphysically rooted in our choices that put ourselves in these situations. Without realizing this connection between the two, we will feel the need to medicate with external drugs.

I cannot say I would never use conventional medicine and drugs to relieve pain. Mainly, the reason lies in my inability to see the reason for my pain. If I understood the root of all my pain, then I am able to fix it myself.

But, I do not always see the source of it, which makes it harder to work with. Resorting to quick remedies seems like the only option without risking a lot of time trying a slower remedy.

But, what is it like when we saw the ailment coming, saw the progression, understood its intention, and knew how long it normally took, because we have gone through this illness before? Do we really feel the need for doctors to cure us just as fast as the illness came in? I would say from my experience, no. Because, I say, "Don't worry, I understand this process from start to finish, and I know how it works." Every time I did not truly understand the process from start to finish, I needed something else to help do that work for me I did not understand or want to understand how to do myself.

Using hunger pain as an example, in my hunger pains, after fasting to curiously see what benefits, ailments, and results were there, I noticed that there were phases of hunger I went through. At the time, I had normally eaten a meal about every couple of hours. So, this was an interesting self-experiment. The first phase of hunger was sensory stimulation and happened about two hours after my last meal. The feeling of "not feeling" was too hard to bare, so I went ahead and ate something. Pushing beyond that barrier next time, I went to four hours. I could move past the sensory pain, because I understood it was just my tongue that wanted food, and my body was still energetically charged. I looked deeper into myself.

The next hunger phase was my stomach shrinking. It hurt differently than sensory stimulation, and it felt like "I was starving." Pushing through that pain, I found out I did not die and was not actually starving. It was actually my stomach resizing itself to accommodate the lack of volume. Then, I went to phase three at about eight hours, where my muscles started aching looking for any sort energy to consume. I pushed through that to find another phase of hunger; performance. Around the sixteenth hour, my consciousness started slipping, where my performance and focus drastically declined.

Keep in mind, I still did everything I would normally do during my day, go to my day job, exercise, write, and I pushed through each phase each day until it became normal to wait sixteen waking hours before eating.

The way I was able to push myself, and especially hold each phase of pain was by being able to see a different purpose in my pursuit. Breaking the first phase of sensory stimulation, I had to realize my stomach was still reasonably full. After my stomach started hurting, I had to realize my muscular energetic level. Then, I had to look past that to realize my performance level. Seeing the pain from start to finish as each wave came helped me move beyond it, now being able to handle more difficult dietary situations.

This process, from start to finish, requires consciousness. If we are not paying attention, then it slips right by us until we are bedridden. What if we paid attention and realized as soon as something felt wrong? Would we not

understand what is going on sooner than later? Then, more can be done in acting on what is about to happen. So, how conscious are we when it comes to our physical and spiritual health? How much are we paying attention to these things? It is a large workload to pay attention to all our relationships in its entirety, as we are limited beings living in limited realities.

This is what aging is; overloading our consciousness to the point where we pop our bubbles and do not know how to deal with it. As we fill our lives with more work, more friends, more family, more knowledge, more bills, and more contracts, we may start to feel that pressure weighing down on us. If we are not able to handle such weight we are signing up for, then it wears us out. Thus, we age. It is just like trying to maintain ten different friendships that are breaking all at once. It becomes very difficult to tend to all the needs of every relationship, and trying to do that requires a large amount of energy that we might not be able to spend.

As children, we did not feel such spiritual weights. Why? It is because our consciousness could handle the responsibility for our lives at that time. It did not matter if we fell on our knee. We had plenty of energy to direct toward the relationship with our knee, while still maintaining an energetic and lively lifestyle. As we grow older, we sign up for more in life. We work more professional jobs that puts more weight on our shoulders, learn more about life that reveals such a scope we had

never imagined, make more friendships and have to break others, manage a family that all have differences that need tending to. We have to deal with more and more energy.

Putting such weights on us without understanding the actual weight can make us snap. Just like a sprained ankle, it was pushed too far too fast for our consciousness to understand what to do in the moment. So, the ankle kept on rolling where the bones, tendons, and ligaments gave out, because they could not take so much negligent pressure. It becomes harder to manage and direct energy toward all of those aspects in our lives all at once. This is why adults feel the mid-life crisis to become a kid again. And, the way they do that is by simplifying their lives. Drop all that weight so they can recover and try a different exercise. That is all aging really is from start to finish, and it comes in waves.

The energy between us also plays a huge role in our health and wellbeing. Have you ever been offended by what someone said to you or to another? When someone says we look older or something of the sort, what is our usual feeling, "Well, thanks a lot. That was rude." What are we actually saying? Why would it actually matter what other people felt about us? We believe their opinion and feeling has an effect on us. It does "matter." Their opinion becomes physical matter as our more wrinkly skin, even weaker joints, and even grayer hair become apparent.

Have you wondered why words affect us so much? What was that entire exchange? It is energy! Someone said

something that created an energetic feeling inside of us. It might have been good or bad. We tend to accept the words of others when they fit our model of life and reject those that do not. That rejection is offensiveness. But, both equally contain energy. We just do not like negative energy. And, the negative energy is what we feel that hurts us.

In this negative energy, we need to understand the power of fear. We fear this offensiveness and judgment so much that we fear them. Just picture this for a moment. What is it like when we experience someone we fear? What is the relationship like? We might end up doing whatever they want. If we are so scared of what they can do, then we let them have their way with us. So, it is wherever they want to go, whatever they want to eat, whatever they want to talk about, and whatever they want to do. We need to understand our fear in the people and environment around us. The more things we fear, then we are just letting them take charge.

We have all felt this in human behavior. What about con-artists? Do they make it seem like they are our friend until they trick us into investing in their "amazing" product? What happens when we understand those kinds of people and intentions before it gets to that point? They no longer have that power over us. We have the ability to see what has happened, what is happening, and what will happen.

Now, transpose that same concept over cellular illnesses and viruses. They are beings, too! They have intentions to

infiltrate our bodies and get something out of us. They use tactics like deception to trick our cells into believing they are friends, and then they diverge to eat us up.

If we do not fear the flu floating around town, then it will not have that same power over us when it does get into our bodies. We already know what to do and how to get rid of it.

Honestly, I believe this same concept does not end at common colds. Of course, common colds are much easier to deal with than bigger illnesses and *dis-eases*. These guys have much more firepower and tactics to infiltrate and dominate what they want. If we do not want to synthetically medicate, it takes much more will power on our part to organically fight them on our own.

There are different types of medication; synthetic and organic. They both come from different places fixing different issues in different amounts of time and effort.

I know we have all seen and heard how plastic surgery can skew our views of natural beauty. It enhances the symmetry and aesthetic liveliness in our skin, face, breasts, butt, fat, and anything else in our bodies time has taken away. What this sort of enhancement does is drastically alter the reality of what was or could be and fixes the (spiritual) insecurity in a very short period of time.

Can the same be said about synthetic medication? Doesn't medication follow the same outline as plastic surgery by

fixing our (spiritual) health in a very short period of time, skewing our views of organic health? Hell, can this also be seen with cell phones skewing our organic ability for energetic communication, being telecommunication? People claim they can communicate without using their voices and cell phones. I know I can do it when I truly focus on communicating without technology, so where is the limitation?

Having technology fix our issues for us in a shorter period of time takes away from our internal and soulful will to work through those insecurities, whether they are beauty or health related. Feel lively about our skin and our skin will be lively. Feel healthy about our bodies and our bodies will be healthy. Of course, we do not always feel this way about our situation for various reasons, but the difference lies in our wishes and convictions.

If we can change the effects common colds have within us faster than before, then what is the difference? There needs to be a change in how we approach colds to begin with. If we know we can heal ourselves of colds with very little aid, then why not with tumors and cancer? Do we just not spiritually know how to yet, or is it *absolutely impossible* without technology? What if we have not learned this ability just as we once did not know how to cure colds? We used to die over illnesses like the common cold, but how do you suppose it became a "common" cold? Enough of us learned how to get through that illness, where our bodies know how to fight these viruses without fear.

So, why do we believe we can heal ourselves with certain types of ailments and injuries in life but not others? "It is just the way it is." Is it, though? How did it get that way? How can lizards regenerate an entire tail if ripped off, but we cannot?

It seems like every species has abilities other species do not have. To me, this shows focus and will power. Some animals focus on certain abilities while others focus on others. The will to adjust to the circumstances is what allows life to evolve to gain and wield these abilities. In illness, if we do not have the will to adjust and evolve, then we are doomed to die from it, unless we call on someone else to make that adjustment for us. It really depends on how we want to go about it.

We do seem to be collectively shifting toward more naturally, holistically, and organically therapeutic processes. We have gone too long using more synthetically produced medicine in the form of chemically manipulated drugs. Now, we are feeling the unnecessary need to use such intense drugs to cure our ailments. Attention deficit hyperactivity disorder is not remedied as much with Ritalin (a pharmaceutical pill used to control impulsive behavior). Impulsive behavior is simply attention control. When our scenery keeps moving from one thing to the other, we create a shorter attention span depending on how often we switch activities. A natural remedy for this is meditation; sitting still, controlling our impulses that

arise, and creating a focus or commitment to one thing over a longer period of time.

Another issue we remedy more naturally is heart disease. It is one of the leading causes of death in America, and what is the main root of it? New science is showing that stress greatly affects the heart. If we are creating a lot of negative energy in our hearts, then it will surely feel bad enough to create a dis-ease; heart dis-ease. What have been their recommendations? We can take walks, ride bikes, spend time with our kids, play a sport, or just move. Using a natural medication such as exercise, we can naturally help the heart continue to move and feel lively.

Even cancer is shifting from a radioactive treatment that kills cancerous cells along with healthy ones to a more holistic treatment. Radiation treatment does not focus directly on the cancer cells. It has to go through the entire body depleting the energy of that person. This is why it takes so much out of people who go through such intense treatments. In Eastern medicine, they do not use such technology to treat tumors and cancer. What do they use? Their hearts and will power is what heals cancer in these specialized hospitals. Doctors do not send patients through machines to do the work. It is done by the people! These doctors create a mantra focused on creating a reality, where the cancer no longer has the control it currently does. They feel this within their hearts, and the cancer goes away in minutes! Ridiculous? It may seem that way to us, but that might be why we do not understand how

to heal in this way. They started viewing their lives in a way they had not before. This new energy was felt, and the cancer could not handle it.

Just like terrorists and "madmen," they cannot handle hugs from the enemy! They know only how to deal with firepower, because they too use firepower. There are people who do not know how to deal with something as simple yet powerful as hugs. This vibration is much different. So, fighting cancer with radiation and chemicals is essentially using fire to fight fire. The cancer comes back for more later on.

Now, I am not talking about hugging fearfully, nervously, "do it to get it out of the way," or because someone else said it would work. I am talking about genuinely hugging because we truly understand them and what they are trying to do. This sort of release is what they cannot handle. It is a communication and intent that does not necessarily "destroy their guts." That is still the firepower energy. Hugs let them know we have learned from them and their purpose is over.

These natural remedies are coming along where we do not need as much synthetic technology surrounding us in order to heal ourselves. We are understanding more about our relationships with our bodies, environment, and the power of our will. It is a beautiful thing when it does happen; we just need to understand we are not limited to healing ourselves *only* through external and synthetic means. We simply create that belief we need them.

It is one thing to have a feeling of appreciation and compassion. It is another to show it. So, when talking about medicating ourselves organically, I am not trying to say the feeling of working through an ailment is all it takes to heal, and then poof, it happens. Just like in any human relationship, we need to feel apologetic for the pain to genuinely feel the apology.

We might need to go one step further by showing the apology. For example, we may buy flowers, run their errands, or anything else we could do to show our apologetic feelings. The same goes with health. Not every relationship, from a human level to a cellular one, *only* needs the feeling. What if our muscles do not only want the feeling of "we'll get through this exercise and recover from it," because they want to feel it on a more physical level? A massage of the muscle, stretching, or healthy foods could all be forms of showing this sort of care. Just as a lady would like flowers after a conflict, muscles could want "flowers," too.

How do we go about this sort of medication? We need to listen to the other. What is it like when we understand our friend and when they are hurting? Do we recognize the symptoms? How did we recognize those symptoms? There was probably some sort of realization that what we did and how we felt in a particular experience was not exactly resonating on the same wavelength as the other. So, things felt "weird," awkward, or even painful.

The question I invite is, "What was done in order for that pain to be healed?" Was it by ignoring them? Was it by

throwing some money at them? Or, was it by creating a heart to heart conversation with them? We did that because connecting with our hearts is the most powerful form of communication. There is no doctor needed when we are being sincere. If we really want to work with our partner in the relationship, then we need to approach it with that sincerity in trying to understand what happened within the relationship.

The same goes with our bodies. We are in a relationship with every single part of it, but when something goes wrong, how do we handle it? Do we ignore it? Do we throw some pain pills at it? Or, do we create a heart to heart conversation with it?

I have been finding that ignoring it is neglectful. And, we do not really like being neglected in our relationships. When ignoring it through turning the music louder, eating, or going anywhere else but into that pain, then the pain is still there until those forms of negligence cause relapse.

Medication does the same thing by creating a form of ignorance from the pain on our part. It also is like buying our way into happiness; maybe buying a new jacket to heal this sadness for the day. We know that we cannot buy our way into *complete* happiness. It is only temporary. Having a heart to heart conversation with our bodies may require very little or no medication or doctors. It is just us!

For example, a muscle spasm, it is twitching like crazy. Is it *just* twitching for *no* reason? How do I work with it? The first thing to recognize is the relationship between me and the muscle. That relationship is, "It's a part of me, and I'm a part of it." That establishes the connection just as any other relationship. In friendship, we feel as a part of the other and the other a part of us.

Next is seeing what happened between the two of us. One friend could say something and the other friend freaks out. What happened? The feelings between the two were exchanged. All the offended friend wants is a genuine apology, and hopefully different or better behavior next time. The same thing happened with the muscle spasm. It freaked out just as the friend did. But, if I feel like muscles do not have feelings, then it is a completely separate issue that needs a completely separate remedy. Let's say the muscle spasm is not a completely separate issue from myself. What if it reacted like it did because I worked it out too hard? What if I did not provide it with enough water? Either way, "I'm sorry," is still an appreciated thing to do for the friend and muscle.

Once I genuinely apologized to my muscle, it actually slowed down its spasms almost instantly. I started talking to my muscle with my feelings, and it stopped. I know this is how it works for the reason that once my attention went off my muscle to something else, the spasm immediately tremored back up. The issue between us was not resolved, which was why my muscle continued to spasm just as any

friend would if the apology and conflict was not hashed out. And then, I put my attention and feelings back toward it, the spasms stopped. The correlation was instantaneous.

As mentioned, it may be hard to see some things as having feelings just as humans, but that is because of our conditioning and societal culture. We only want to see humans, dogs, and other select beings as having feelings. What we are really saying is, "I do not care about any other's feelings than those I deem worthy." But, if we wanted to communicate better with the rest of the world and life within it, we have to move beyond that scope. All things have feelings. Being able to work with the Universe on many different levels is what realizing the feelings within all can do.

If we want to fix or medicate our relationships, we have to first understand there is a relationship and work it out with our feelings. Not everything in this Universe speaks the same language, so we have to start trying to speak a deeper and more "felt" language.

Where does health come from within a relationship? It comes from a place of trust. Kissing; we are exchanging bodily fluids with those we trust in the moment. If it is a stranger's saliva, it is perceived as an infected petri dish! Honestly, what are the chances their saliva is that much worse than the person we just trustingly kissed? The difference lies in our trust. We do not always become sick after kissing someone, but eating a stranger's half eaten meal might just kill us. We might justify it with the

reasoning, "Who knows what could be in it?" The reality is that every friend was once a stranger.

What if we trusted (believed in) the saliva of the stranger? What if we did not view it as being so gross? Would we metaphysically hurt the way we do?

It is because they do not trust their bodies and themselves in dealing with energies from a perceivable stranger. They do not want to deviate from their comfort zone even just the slightest bit, because it could potentially kill them. Then, they turn to the doctors to look for a label, reason, and remedy.

As children falling over and hurting ourselves, we immediately looked at our parents or surrounding adults to see what we should be feeling after the experience. If the parent looked frightened, then we probably started crying. If they did not look as frightened, then we probably brushed it off. This shows a lack of trust in our own feelings at such an early stage in our lives, and we continue to grow older looking at other's perception of ourselves in order to know what to feel in the moment.

As adults, we still do not trust our bodies and ourselves to know what we feel and especially how to deal with that feeling. So, when something makes us feel a certain way, we turn to "those who do know;" doctors. They then give their medical opinion and prescription telling us this should fix us, because we did not pay attention to how we got into the mess in the first place.

Kissing our life partners, we do not even think twice about what is in their saliva or if they washed their hands that day. We trust them, and we are willing to go through the potentials of this experience. Dogs lick their genitals and eat their own feces. Yet, so many of us let them lick our hands, faces, and even inside our mouths. Yes, I have seen this. Why don't we get sick more often considering where their mouths have been? Is it really because "a dog's mouth is more sanitary than a human's mouth" like I have read in various articles. How is that possible considering what humans eat compared to dogs? If a person licked their genitals and ate feces, there is no way anyone would knowingly want to kiss them, touch them, or even look at them! With dogs, we trust them. They are cute, obedient, and playful; all the things that overpower the realization and feeling of disgust of their genital lollipops. It is accepted, but if a human did this, they will be forsaken from all civilized socialization for the rest of their lives.

This is the power we give others in determining what will or will not have control over our health. We have to trust and accept the person that potential illness came from. Just widen the spectrum of trust to include friends, strangers, animals, plants, and life. Then, we might not feel so sick being out in "disgusting" nature. We just have to appreciate and trust others more than we currently do.

To heal our relationship, whether it is with a family member, friend, stranger, animal, internal organ, cell, or

anything else in this Universe, we need to want to work with it.

Hugs are good. Isolation can be good. Food can be good. Play time can be good. Projects can also be good. And, even simple parent/child interaction might be all that is wanted. Not doing that might create more problems in the relationship down the road. Using a pain pill every time our head hurts may take care of the problem at the moment, but what happens down the road? What happens when there are no more pain pills? What if we took care of our bodies in a different way by understanding and appreciating the relationship we have with it?

I do this with my body and personal relationships for a good portion of my aches, pains, illnesses, and whatever else. Of course, I am not completely in tune with my body and relationships, or else there would not be any of these conflicts to work with in life. Paying more attention to what my body likes and dislikes and what I like and dislike creates a more harmonious relationship with my body. I can heal headaches, aches, muscle pains, and spasms in seconds, because I know how to talk with my body and the pain it is going through.

Remember, we all do! We all use medication for something. Some people take drugs, shop for clothes, flip on the television, eat ice cream, read books, play sports, hang out with friends, work at the office, write music, and anything else we do to relieve the previous focus we might have grudgingly felt

obligated to do. And, people also do these things not for medication. It is all about our intent in using them.

Do we understand when we are using them for medication? I will say that when we do, we get a better understanding of what is really in conflict within ourselves and others. After that, we realize why we feel like the medicine needs to be there, and what the medicine does that we can do ourselves. That has been my experience when realizing the many things I was using for medication to balance larger imbalances in my life. Personally, that is why I used drugs, watched porn, and hated work. These were the big issues in my life, but I realized why I felt such a need to use them. I was looking for a remedy to relieve a spiritual conflict within me I felt like I could not handle on my own.

Do not get me wrong, I needed those things before. Without them, I would have done some crazy things out of intense amounts of stress. So, it was a necessity at that stage of my life. But, once I realized where and how deep the pain ran, I could then touch it and work with it. The need for medications started fading away, realizing they did not serve the same purpose as they used to.

"No problem can be solved from the same level of consciousness that created it."—Albert Einstein

Manifesting Life

Manifestation; it sounds like a magical word, but does it have to be? The word broken down is man and infestation. Humans infesting reality. Gross? Maybe, but infestation is just reproduction and expansion. Isn't that what creation is? When we want to provide many cars for many people getting them where they want with faster mobility and less effort, there is a manifestation of cars. A factory full of employees (humans) builds and distributes cars (infestation) to the rest of the world (expansion).

Do our manifestations have to only be things we build with our hands? Absolutely not. We do see a lot of manifestations built by our hands; cars, houses, roads, clothes, electronics, and etc…Although, the realization and understanding does not have to stop at our hands.

Creation can happen on many different scales and dimensions. Diving a little bit deeper into this realization, what are those cars made of; metals? Other people will recognize that without these metals, there would be no such cars, at least, the ones we have today. What are those metals made of; elements? What are those elements

made of; atoms? When we look at newly built cars, we understand the will of the organization is what manifested those cars into being.

If our human hands and a lot of will power can create these cars zipping around the surface of the Earth, then how do atoms come into existence zipping around the surface of cellular bodies? Is it "out of our hands?" I believe not, and I believe we have much more participation in the creations of the Universe than our societal programs give acknowledgement.

Basically, most humans will say we have the ability to build cars, because we generally understand the tools and metals involved in the process. Though, most of us would not know what to do with those tools and materials. So, we understand the possibility as long as we have the wisdom and will power to build a car. When neither are present, building a car *is* out of our hands. The same goes with the creation of physical matter and reality.

After breaking this boundary of creation, we might be able to see more of how we are all building more than just cars. This can span from atoms all the way out to the cosmos! Why is creation limited to *just* normal societal creations? People come out of other people! That is incredible in itself. And, what does that take? Some food, a lot of patience, and even more will power.

This manifestation spans many scales. How do cells come into existence? What about elements, atoms, sub-atomic

particles, and so on? Was it by randomized accidents or by an intelligent programmer? This is where we get into the good stuff…

Was the big bang, an infinitely dense, finite grain of rice containing all of the matter we experience in the Universe, the start of it all that put everything into "accidental" motion and spin? Of course, most scientific perceptions would say, "It sure did." But, aren't they missing a very important piece? Where did that grain of rice come from, and what exploded it? What even happened once the initial explosion was done? Is science missing some stuff, like intelligent design? Is it a bit ignorant to say everything we see and experience here on Earth and in the Universe is an accident?

The flipside of this is the more religious and godly perception, where everything was created by one entity; god. Who or what is that god is up for interpretation, as every religion and person has a different feeling about it. An all-intelligent and powerful god is the main theme, though. Everything is due to this god, and without *him* (why is this god masculine), there would not be any of this.

But, just like the scientific approach, isn't this missing some stuff? Where are we in this picture; puppets? Did this god create our lives, where we really had no participation in what we did since he is planning it all for us? This takes a lot of credit from ourselves, which can feel disempowering.

Evolution is a big topic for a lot of people. Do animals randomly bump into an accidental genetic exchange which produces a slightly different kind of animal, or is there some intelligent god programmer telling life how to evolve? This is the great battle between science and religion. Science explains life without intelligent design no matter how complex and intelligent life is, while religion explains life without the constant evolution that is each generation. To me, both are right, and they need each other.

But, both perceptions of life just explained miss one thing; us! Where are we in this picture? Science said everything is random, which leaves our will power out of the creation. Religion said everything is due to this one god, which also leaves our will power out of it.

How about we start considering life as a co-created experience. Without you, I could not be me, and without me, you could not be you. We all play a role in this party called life. We are not just "at" the party. Each and every one of us makes the party. We are constantly creating life as we believe we should. This is how everyone is participating in exploring and creating life.

As conventional science explains, our genes are "read-only" codes and are only changed by extreme "external" mutations, but progressive science is finding out they are not! How is that possible? If genes can only be altered through mutations, then what causes a mutation? Some might believe mutations occur through procreation,

mixing abnormal genetic code to create a mutated gene. Still, this does not explain how the original abnormal genetic code occurred. Eventually, people dismiss it by throwing it to the environmental conditions, since that seems separate of our human biology. Then, we do not have to include ourselves in the participation of the mutation.

Believing genes are fixed is simply the lack of care to evolve them. We would rather leave them as they are than put in the work to change them as we wish.

According to studies done by Dr. Bruce Lipton, genetic evolution is based on perception! As we perceive something about ourselves and our environment, we change our genetic code in accordance with that perception. Evolution is a choice.

For example, what is a savings account? Are we worried about not having enough money down the road? We create a savings account just in case. Looking at a cellular level, what if we feel like our environment does not contain enough nutritional energy for sustainability, then we reserve that energy as fat cells in a savings account. Why do women "naturally" carry more fat cells than men? Women carry another human within them. Carrying extra fat is simply keeping provisions for their baby. They usually were not the ones hunting and finding food. They had to wait for the men to bring it home. And, did they really know when that was going to be in those days? The same goes with men being able to grow more muscle

faster than women because of an increase in testosterone levels compared to estrogen. Our perception was that we needed the capability to last long periods searching and killing animals for food. So, our genes felt that perception, evolved to build more muscle faster, and call it testosterone. In times of men feeling more feminine, their testosterone levels decrease based on who they are and what they are doing. What would you suppose regulates that? It is not separate of their spiritual energy, no matter how much they want to separate themselves from that biological chemical within them.

Our genes can be molded into whatever we feel we need as we go through life, which means we are constantly evolving our genes. Our parents do pass on their genes in that current state during conception, but the baby will go through life evolving those genes based on their spiritual choices and perceptions throughout their life, just as their parents did. It is a constant melting pot.

Alcoholism runs within the genes of a family not only because of random and natural selection. It is also because of choice. Someone believed it was useful to consume such levels of carbohydrates that their genes evolved to tolerate those levels. Eventually, it became a "necessity" to feel those levels of carbohydrates at those particular intensities. Then, they procreated, passing on that evolutionary choice to the next generation to deal with. The next generation has the choice to continue the family tradition or change it.

A simple and local example of genetic modification was when I *used* to be lactose intolerant. Anything lactose created violent and painful experiences in my intestines. People told me it was genetic, and I should avoid all lactose related foods. I could go that route between the "fight or flight" options. But, I did not want to do that, as I enjoyed eating particular foods with lactose. I slowly fought by introducing my body with lactose in small doses to build a better relationship with it (tolerance). What would you figure? Within months, my stomach did not feel nearly the same level of irritation as before. It was a relationship I cared to be with and evolve.

Others have done this with snake venom and poison ivy. They worked with poisonous snakes and plants so much that it meant a great deal to develop that relationship. After enough minimal and incremental exposure, they developed a general immunity. This was all because they wanted to evolve their genetic code to handle such foreign energies on a regular basis.

This perception to change is the very reason why scientists say terrestrial life once came from the sea. Intelligent design is subsequently the very reason how it happened. The intelligent design comes from each and every one of us choosing to evolve ourselves how we would like to make our realities.

Just like not getting enough nutrients from vegetables, we tend to feel tired, sluggish, irritable, imbalanced, less conscious, and possibly ill. Why is that? Maybe, it is because we chose to eat vegetables long enough throughout

history such that our bodies evolved to feel the nutrients from vegetables on a regular basis. The same evolution can be said about cigarettes. What do chain smokers say when they do not get the nutrients (energy and stimulation) in cigarettes? Are they tired, sluggish, irritable, imbalanced, less conscious, and possibly ill? Of course! That is called withdrawal created from a heightened tolerance.

The same sort of withdrawal can happen with vegetables. If we consume something long enough, our bodies start to adapt to it, which shows tolerance and evolution. Smokers "need" nicotine in their system to feel normal. If they do not, then they do not feel normal. And, most non-smokers would tell smokers, "You're choosing to do that to your body because of your perception of life." Therein lies how perception changes our genes and our bodies!

Essentially, if enough people over enough generations continue to drink smoke cigarettes just as we continue to eat vegetables, then we would evolve our bodies to "need" those nutrients.

Another way to look at our participation in intelligent evolution is by driving in cars (yes, another car analogy). We get to experience the luxuries of air conditioning, windows, seats, and many more depending on the model. We may look at these things as *just* being there, but the question I would like to ask is, "Why are they there at all?"

The answer is simple; we wanted them there. We wanted cars to have air conditioning, windows, and seats.

Someone had the will to figure out the logistics and process in making these luxuries a reality. Later on in the future, a scientist might come across one of these luxurious cars and study it, realizing the various amenities and features. They would see that cars of those days had certain capabilities based on the belief and will of the people that created them. "Hmm, people must have been wanted cooler air to breeze through the car, because the temperatures were harder to bare back then," might be an assumption coming from this scientist. They realized the car was built upon the perception and belief of what those people wanted to experience in life at that time.

Now, to show that same sort of belief and will in manifesting our Universal reality, our human bodies are the same way. Our souls and will power construct our physical reality the same way as an engineer invents amenities for a car. Those features serve a purpose just as our eyes, mouths, hands, hair, blood, genetics, and atoms serve a purpose in our bodies. They were not *just* there for *no* reason. We felt like this was how we wanted our bodies to be after enough varying experiences.

Based on this realization, science is now a discovery of our spiritual perceptions in life! Science helps show us what we have created and are creating. Picture it like a snapshot of our souls' intentions. When science studies something, it creates a portrait. That portrait is based on our spiritual choice and how we want to make life for that moment. Do not look at this Universal creation just from

the perspective of humans. There are many other beings out there on this planet co-creating as humans do.

After seeing a glimpse into our capability in evolving life, we have to understand a key component of it. Spoken language is something a lot of animals, especially humans, seem to use in expressing our feelings. Though, we all seem to use slightly different symbols to represent what we are trying to express. Some labels use particular sounds and letters. This is essentially what language is; a common understanding representing something in life.

There are many different kinds of language spanning from verbal text to physical gestures and even unseen energies. But, it seems like each dimension of life has its own language. Mathematics has numbers, physics has atomic force, chemistry has bonds, biology has genetics, sociology has linguistics, and astronomy has gravity. All languages can be interchangeable, since all life is connected to one another. No language is separate from another; though, we just might not understand how to speak these other languages.

To communicate with other humans, we use words to express our intentions and feelings. We have developed them into the current stage of language, but where did it come from? Did it just appear this way, so it then has to always be this way? Just like the common perception of evolution, animals and life on this planet did not just fall from the sky as they are. There has been adaptation based on the animals living in those bodies. So, language

has done the same thing. Although, we might not see how language has evolved throughout the ages depending on our exposure, be certain it has. Though, be certain it has.

How did language become what it is today? Well, we simply changed it! Some people blended two words together that most people might have separately used and made into one. This is a simple contraction. This is just one of many changes and evolutions made in human language. There have also been progressions in how to use words. We created prefixes, suffixes, adverbs, participles, and such to show new dimensions of expression. We are even changing definitions to words. The plural noun "guys" was formerly used specifically for the male sex. Now, Western society has been using it for male and female sexes. A funeral in West Africa is actually a celebration and not a mourning of the passing life. They view it as a transition into a different place in the Universe. That is surely not how Western society defines a funeral. How and why do you suppose these changes within the same concept occurred?

We decided to move language in the direction it is currently in. There is not a god entity deeming what is going to be the next wave of language, as the servants have to learn these linguistic updates. I know a lot of aspects in our society seem to work that way, though. We do not see how much power the people have in this evolution. If enough people start using particular phrases in particular ways, then it becomes conventional and understood. Just as paper money only has power because we all agreed

green paper holds a certain value. It is understood. As soon as the people stop believing in green paper money, it will be understood it no longer serves a purpose in human reality.

That is the most important part about this evolution; is it understood? If it is, then the language gets rewritten. The parts of speech that are more frequently misunderstood are left to gather dust just as our appendix or tonsils have. Essentially, we get to decide what is and is not in the language.

Are these other languages in mathematics, physics, chemistry, biology, sociology, and astronomy fixed as we believe? Seeing how the human language can evolve when we choose to mold it, can something as fixed as mathematics be evolved into something else? It is a language; one that scientists say is a "universal language," since numbers are everywhere.

But, how did these numbers get there? What even is a number? That number is a representation of space, time, and life. "This number takes up this much space over this much time." When statistics are taken from attendance at a conference, that number represents how many people willingly chose to be at a particular space at a particular time. It is a spiritual representation of a physical manifestation. Language is a representation of life, so what does that number represent in life? We have just broken a barrier to understanding what is behind this language on a more intimate level.

Looking at another example about how far this soulful creation can go, let's peer into the laws of physics. Einstein's law of relativity explains that space and time curve depending on force or gravity between two in relation to each other. Light bends through space as it constantly has attraction toward and aversion away from stars, planets, moons, people, animals, and anything else in the Universe. As we get closer to a more massively dense body, spacetime gets stretched even more, where time slows down and space gets closer to an infinitely dense singularity.

But, spacetime relativity does not have to be limited to astronomical scales. Einstein's more humanistic analogy states, "Put your hand on a hot stove for a minute, and it seems like an hour. Sit with a pretty girl for an hour, and it seems like a minute. That's relativity." What does this mean? Does time fly by when we are having fun, but when we are not having fun, it takes an eternity? Are we adhering to something else's laws of physics? Some might say, "Yes," but, others might say, "No, we're creating them."

Einstein's law of relativity in physics can be transposed over human perception. We choose to like or dislike something. We choose to gravitate toward or away from something. In essence, we are creating the laws of physics to act the way they do.

Now, I realize we may not feel so contributive when taking into considering the micro and macro scale of the

Universe. Of course, there are limitations to everyone's abilities. We cannot seem to make planets change their orbits just by a few people willing it to happen (at least not at this point in our journey). Let's be "realistic." But, with enough people, we *can* change a culture and make it rain. This is prayer, meditation, mantra, focus, will, or anything else we want to call it. Why throw out the possibility? If it can happen on a human level, why not on any other level and dimension?

In order to create, evolve, and change life, we need to feel like there is a purpose in doing so. This seems to be a big issue with a lot of what we do with ourselves. "What is the point," or, "I work here, but I do not see much purpose continuing." When we do not feel a purpose in moving somewhere, it becomes harder and things stay still. The pain and reward cancel each other out, and it is a stalemate.

This same law can be found in physics presented as waves. When two waves of the same frequency and amplitude encounter eachother, they cancel each other out. But, as two different waves meet, a differential is created. This differential and interaction creates a lip and a spiral.

Just like a tornado, it is manifested through a differential in pressure; high pressure from one side and low pressure from the other. This is torque, rotation, and dynamic spin. From the Italian mathematician Fibonacci, life originates from The Golden Ratio 1.618. Through this mathematical coding, things conventionally spiral through this geometry going in and out of existence.

How does the Fibonacci ratio work? Just start with singularity being one and only, and then create duality by polarizing it; 1 and 1 (or love and hate, good and evil, masculine and feminine, white and black, yin and yang, or any other dynamic). Together, that makes 2. Now, add the previous number to the sum (1 plus 2), and that makes 3. Add 2 to 3 to make 5, 3 and 5 to make 8, 5 and 8 to make 13, and so on.

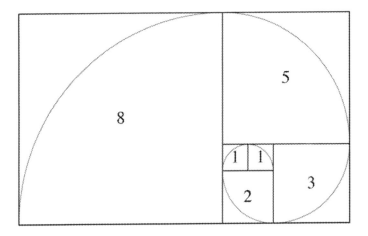

Continue this process to create an infinite loop outward or inward. It is never balanced, because then there would not be any spin generated. The two original energies would cancel each other out (1 into 1, 2 into 2, or 3 into 3).

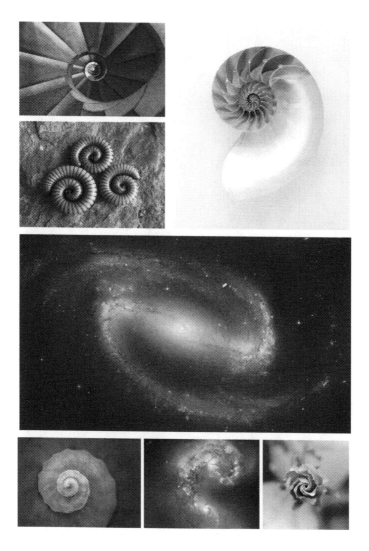

Everything is curved, which means everything spirals. But, how can even the smallest of particles "appear" spiraled instead of solid spheres as we are conventionally taught? Well, we have to throw away the understanding that matter is separate from space, and instead realize that matter *is* space. Matter is pulled together from the fabric of space and is twisted into being. There is no real separation of one thing from another. Then, seeing how everything is connected and manifested from space itself will truly sink in.

Here is another visualization of that connectivity. Picture a large body of water or an ocean. There are waves of many different sizes and speeds. They bump into each other creating differential waves, which inevitably either spiral in the body or curl toward the shore. So, we have swirls manifesting in one particular place. Then, another swirl manifests. As another manifests, they pop up all throughout the body of water, not just on the surface but within the body as well. Though there are so many different kinds of swirls, it is still one single body of water, where every swirl is connected at a distance.

Adding an extra dimension to this concept, there can also be swirls within swirls. As seen in these illustrations, there are swirls happening throughout the entire body of each image.

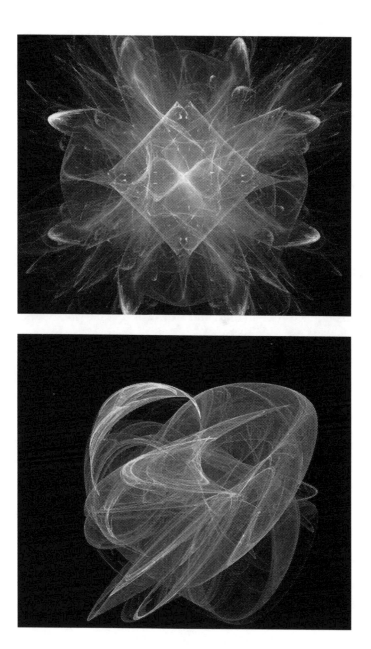

In a 4D body, the "fabric" of water can overlap unlike the folding of paper in 3D. One side of the paper cannot quite go through the other. This overlapping is one aspect of how everything is connected. It is one single body where the activity (conflict) happens, but each swirl can be traced and connected to all other swirls. A torus (two-sided vortex) is like a wormhole from both ends, but a wormhole is not separate of all other wormholes. They are all connected. The same principle stands within space and energy.

We create the change we want to see. But, where does movement originate? In order to get something to move, it has to come from a source of soul. Our souls want to experience this change and evolve life. Take your hand and hold it up in the air. It is not moving and is floating in space. Now, tell it to move. What happened? It moved! How? Your will power did it! You communicated, "I would like to move this particular mass of energy," so the trillions of atoms in your arm communicated back, "Let's do it." At the atomic level, you just soared trillions of solar systems through spacetime because of your will. Isn't that incredible? Your hand was once motionless, and you then wanted it to be in motion, so it went in motion!

Things move for a reason. Is it "just because they move?" There is will power and consciousness to everything, since everything was once still and is now moving. Manifestion is movement, and movement takes soul.

Each of Our Gods

God seems to be a very sensitive subject for most. What I have always wondered with others and myself is, "Why is this the most controversial topic ever discussed in history?" We can talk about anything else, but when someone tries to express their perception of God, the world collapses. Because of perceptual differences in what others believe is God, we feel like they take away from our own belief in what is God. "You're trying to tell me God is different from my own belief." This can frustrate us, since it belittles our understanding of something so divine. It is hurtful, especially when we are not looking for alternate perspectives from our own. We enjoy our connection with our particular belief of God. Even for those who do not believe in God, they can still become worked up about the concept, which indicates some sort interest in the matter, just in the negative polarity.

For this topic, take what you will and leave the rest, but please be open about what I am about to share.

How often have people expressed what they felt was God? What was it? Some would say God is a wrathful fellow.

Do not disrespect him or he will show you the limits of his mercy. Some would say God is a compassionate being with an understanding about life we cannot comprehend. Others would say he needs our love and worship or else he will not love us back. Right there are descriptions of three different people, or this god is "tripolar." I am not trying to make anyone not believe what they want to believe about their perception of God. What I am trying to do is show how everyone has a different perception of who and what this being is.

Though, claiming this single god entity is credited for every single event, experience, relationship, feeling, decision, and will of any being in the Universe is quite a bold statement. It takes away from all of the life living in the various bodies creating life as we live. It means we did not actually do any of the things we did in life; the struggle in relationships, work, and everything in between.

It would be like people believing Santa Claus gave the children all their presents. This god-like entity is claiming all of the struggles the parents went through and hijacking the enjoyment from the children when they open their gifts. The real gods of Christmas are all the parents that worked their butts off to get their children these gifts. They are the ones who deserve the credit from their children, rather than this single imaginary god.

Until these children realize Santa Claus is not real in the sense that the common culture is describing him,

their appreciation is not going to be directed toward their parents until that time. Christmas turns into a much different experience realizing the gifts given to all children, family, and friends was not due to this one single entity. It was due to all of the hard working parents for their hard work and sacrifice, along with the children for being a part of the family each and every day. Each one of those parents and children are Santa Claus. Each one is God, because it takes all of them to make the experience.

My view is that the disciples of Jesus wanted to be like him so much that they bypassed what he was trying to teach them to see, which was that in order to be capable of doing the things Jesus could do, they needed to find God. Since Jesus preached about God being within him, his disciples only looked within Jesus, rather than also within themselves.

The belief that God is only within Jesus was misunderstood. Jesus was actually trying to get people in touch with their own centeredness and God that resides within all, not just Jesus. Jesus is the only one who can be Jesus. And, we are the only one who can be us. No one else can be us, just as no one else can be Jesus. We will never be able to achieve what Jesus could by trying to duplicate Jesus.

We view celebrities and idols the same way. What is it like when someone really admires the work of a professional athlete, musician, or scientist so much that they cannot see it within themselves? When on the job, they seem to make *no* mistakes. How is that possible? Where is that

line being amateurs and humans but flipped into masters and gods? Of course, if we have little insight into what these professionals do, then it would be very hard to see their "mistakes." I know, because I have done this with particular people I idolized in different aspects of life.

After watching the professionals, it seemed "seamless," perfect, and godly. Nothing these professional athletes or musicians did was wrong. Even when the athletes lost the match, I still thought they were perfect, because I could not understand how they lost. But, guess what? Both the winner and loser were not perfect!

Putting them on such a high pedestal made me not critique their abilities, where I accepted all they did as godly. "I could never achieve any of that, because I'm just a mere amateur, mortal, and human." Once I feel that way about something, I immediately limit myself from achieving those abilities. Ask any professional, "How did you gain the ability to understand and perform the things you do?" What do you suppose they say? "I didn't want to limit myself by feeling like it was impossible, so I made it a possibility." Isn't that something? When they saw the top professionals in the world, they did not cringe in their presence in fear of disappointing them because of their inabilities. They knew the top professionals were still human just like anyone else.

These professionals will be revered as the gods of the sport, but asking them how to be like them, they will tell everyone, "You'll never play like me, because I am

me. You need to play like you, because only you are you. Everyone has a different style and approach."

Nowadays, this belief to be like someone else is so engrained into religion and society that it is disrespectful to make any claim of being Godly. We are all Godly… in human form…for a little while. We are a part of God, just as God is a part of us. Not seeing this does not make us any better or worse, because not everything in the Universe *conceptually* knows about God, yet they all still seem to live lives just as any human who does conceptually know about God. What is the difference? Dogs have no clue what God is. Are they damned to hell for all eternity, because they have not been to church or cannot physically make the sign of the crucifix? I would not like to discriminate by believing they are doomed.

Let's think about this for a minute. We are all people living lives already. Our bodies are moving and doing the same things as any other body. So, how is it that we need to be able to do certain things in a certain order to find God? It is like believing there is only one way to Africa even when the world is round. It doesn't matter which direction we go, we will end up there. Though, there is a unique and direct path to Africa from every single person's location.

Faith; the driving force that keeps us moving into the life we want to live. People say faith is God. I agree and disagree. Faith is God, and God is simply whatever we put our faith into.

Dogs do put faith into something. Maybe, they put faith into a tennis ball being thrown across a yard. Maybe, they put it into their parents coming home after work. Maybe, they put it into cuddling with a baby. That is their faith.

Faith means worth. It is *worth it* to put our energy toward this aspect of life. There is purpose in it. So, to say someone does not have faith simply means they do not have faith in what *we* have faith in. Does it mean they do not have faith? No. It is just placed in a different purpose than ours.

People put faith into throwing a ball into a basketball hoop, running a ball down a field, plucking strings on a guitar, painting a waterfall, going to church, raising children, counseling adults, loving a partner, and anything else anyone does in this world! We wake up to do these things, because we feel purpose in them. We are the healthiest when we are with what we put faith in. We are the weakest when we are not with what we put faith in. When someone else tries to make me put my faith in something I do not believe my faith should be, then I do not feel the healthiest.

My God was racquetball at one point in my life. I woke up every day to hit a rubber ball up against a concrete wall in a 40 foot by 20 foot box. My faith in that sport made me feel more alive than going to church worshiping some other guy. Was I lost? Only when I went to some else's church. And, the same can go for those who put their faith in church rather than racquetball. They may feel

more alive at church than in a racquetball court. Who is right at this point?

If God is simply our own passion for something in life, what is it like when we are in this *godly* state? Our presence is heightened, we get into a flow, we do not seem to be deterred by pain, we understand the ups and downs to every situation, we are motivated to go on, every single moment is unique, every single being contributes to make the experience happen, and our love is unconditional.

This state is passion, which can be summed into a feeling called happiness, but notice when we are not with our passions. What is it like? Our presence is lowered, the flow is staggered, our health declines, energy decreases, we are less curious, we play the blame game, feel like victims, and we are not as hopeful for life. This can be summed into a feeling we call sadness when not with our personal Gods. When we do not get to live what we feel is our purpose, then we feel sad and ill. This is depression. We are not in touch with our God.

But, the most important thing to point out is we all have our own God and faith. Just because we do not go to church or worship another religion's God, does not mean we do not have faith. It means our faith is not exactly where they put their faith. That is perfectly fine. This does not mean we are lost.

If we all have a different perception of God, then that is how we want our God to be. Picture someone telling a

group of people to paint their ideal house. Everyone paints a different house, because it is what they considered to be a house. We all have our own version of the house. In essence, *we* are creating God in our own image. God is what we make it. If it is a "he," then it is a he. If it is a "she," then it is a she. If it is a human, then it is a human. If it is nature, then it is nature. If it is energy, then it is energy. If it is the Universe, then it is the Universe.

We decide who God is. Essentially, we are all God! God is what and where we choose to put our hearts.

Our "Bigger" Selves

I have no clue why I do the things I do in my life. Do you? Have you ever really known what the point of our actions were before we did them? We did them to see the point. The main thing to see with this is we still acted the way we did without exactly realizing why. So, where did that come from? We can retrospect after the fact, but we first had to move through that space in order to retrospect. It is our higher self already setting that particular purpose in a particular space as we travel toward it.

The hard part is feeling how large our higher selves can be. After this realization, I no longer want to call our divine self as higher; rather, our "bigger" self is more suitable for how I want to explain this aspect of life.

To begin this concept, ask the question what is it like improving an athletic skill or ability? What happens throughout the process? At first, does it seem like a blur, because everything right in front of us was moving at the speed of light? Being at a "smaller" state of consciousness (this does not have to be a bad thing), it is harder to retain more aspects of the experience and keep up with the pace.

A beginner has very little awareness of the playing field, mechanics, strategy, and conditioning it takes to really play that practice at greater levels. This is why beginners can be beaten and do not understand how it happened, especially when the skill level is heavily swayed. That opponent simply had more awareness of things happening within the practice. They had more experience understanding what happened, how to work with it, and saw more avenues to choose from. The beginner might have barely been able to keep up with focusing on the ball, let alone the court positioning, swing mechanics, shot selection, and cardiovascular conditioning. It takes much more energy to be aware of these things from a greater perspective.

This grand perspective, though, is the "bird's eye view." Everything seems to move much slower when we are so far away from it, but when we are right up to it, the experience moves too quickly to see. If that is how we expand our consciousness to larger scopes, then the question is, "How do we get to this bird's eye view?"

Place a picture inches from your face. You can see only but a fraction of the entire picture, and when that picture moves sideways just a little bit, that focal point jumped so fast we did not see what happened. We are now at a different region in the picture, which means we are getting familiar with another part of the picture. We explore different parts of this picture close up to get a "feel" for the overall picture, but we have not been able to put all the pieces together, because we are still so close to the picture.

What happens when we take a few steps back from that picture and put all of those pieces together? We can see more of the picture and understand it all together. This is how consciousness works. When we are more conscious, more things are noticed. We understand the connectivity between more aspects of life, and we understand the purpose of these aspects.

I am not trying to *only* promote conscious expansion as *the* point in life, as we all seem to have different pursuits of where to expand and contract ourselves. It would be very difficult to expand ourselves in every aspect within the Universe. Being fully aware can be overwhelming if we are not intentionally conditioning ourselves to do that. It would be like running a marathon when we only run a mile a day; it would hurt. The marathon is eventually possible, but we need to work on many other aspects in our lives before we take on such a feat without hurting ourselves for future races. We need the rest, break, downtime, relaxation, and ease along with it. In this process, we push ourselves to expand our consciousness, then take a break to recover (contract), and expand, then contract.

I know, what does this have to do with our bigger selves? It seems like there are many dimensions to this Universe; not just the ones we see with our eyes, hear with our ears, and etc…There are many dimensions within life that can be tapped and touched, but if we are not trying to reach them, then we are working from a limited or smaller state.

For example, we really enjoy the philosophy that beauty is on the inside. The inside of what? Where is that beauty? We can see skin and bone, but we cannot see "inside," because it will just be made up of smaller units of matter and then smaller units of those units. There is no real "inside." This is exactly what I mean by multidimensional. Beauty is not just how our skin and bones are composed. It is the soulful experience, embodiment, and expression of our bodies and all other bodies around us. Beauty can be found in smooth skin, flowing hair, pleasing aroma, and fresh clothes, because it shows they physically and spiritually take care of those things. But, what about also embracing scarred skin, nappy hair, smelly aroma, and dirty clothes? It shows we are not perfect and have been through the rough side of life as well. This aspect of us comes out when we understand both of these traits in life to see the grand picture; the good and the bad, the glamour and the crap, the shallow and the deep.

So, the deeper sense is connecting with a more invisible insight of life and a divine creation. We all have a plan for ourselves. We all want to experience certain dynamics and dualities within life; clean and dirty, pretty and ugly, work life and family life, good and evil, love and hate, masculine and feminine, and any other duality experienced, as there are many more and on many different levels. Experiencing different intensities of these dualities, we learn these dynamics being energy, and we are able to understand these energies later in life.

Look back on an experience when learning the taking side of the give and take duality. Did you unjustly take a particular amount of money from another without letting them know? How did you feel? What did you do next time when in a similar situation with a similar amount of money? What if you were on the giving side as money was taken from you? How did you feel? What did you do next time? Just picture all of the good and bad experiences we have gone through lasting hours and all the way up to years. Some of those experience, you might have reflected and realized the purpose of losing your job to find your professional passion or being at that restaurant to meet your life partner. Maybe, you dropped the fork in the kitchen to pull your lower back muscle leaving you with time to spend with your family for three months. These are the subtleties we may not see as being connected and having purpose.

We experience and move on if we pay attention to what happened, or we experience and repeat the cycle if we do not pay attention. This is a characteristic of what consciousness does. When we do not pay attention, then we keep repeating the same cycle of conflict within the same duality, until we wake up from what is happening and choose a different direction.

Though, for these experiences and lessons to work the way they do, there has to be a plan for them; the divine plan within us all. This is based on agreement. We already work with agreements on a more human and local level by creating

written contracts with others. We want to buy something that someone else wants to sell, and we create a contract for that to happen. The same goes with marriage. It is a contract saying we will be together all of our lives. This same concept happens at the deeper soul level with each experience.

Though, we do not seem to sign contracts with pen and paper for them to happen. We move into that spiritual space to make it happen. If I want to feel what it is like to steal from millions of people, I will end up making it happen, only when those millions of people equally want to feel what it is like to be cheated by one person. It always takes two parties to make a relationship and a singular experience. But, our smaller selves do not see what is going on until after expanding our consciousness.

In essence, expanding our consciousness can help see the connection of our bigger soul plan in agreement with everyone else's soul plan. It is an agreement that cannot be broken at this lower level. We can break sales contracts and get divorces. But, what is it like when we do not have these written contracts when exchanging goods and services or staying next to someone's side? As we get deeper into the soul, things are harder to move and change. We simply just *need* to do it. These are the agreements that run much deeper. There are no papers making us do it. It is in our souls to exchange these goods, be with that person, move to this area, or leave a friend…

This is the purpose that is every single interaction, experience, and relationship within the Universe. We are

all separated from everything and at every scale, which means we are all actually connected at a distance. We are in a relationship with everything, so we are experiencing everything. As we start to see the purpose in every single interaction with everything (not just humans), then we start to connect with our bigger selves by seeing the co-creative agreements that is this Universal experience.

But, where do we go to connect with our bigger selves? When following our hearts, we do what comes. It seems like it is the most obvious choice to make in the situation. What else is there? Throwing around "what ifs" is when the decision becomes more and more difficult. This puts more of our decision into our brains rather than our hearts, calculating every possible outcome in the brain. Since there are infinite possibilities, then our calculation will go on for infinity and never making a decision. Rather, make the decision from the heart.

During performing any practice; athletics, music, or art, the flow of that practice is much more difficult when we are constantly calculating and thinking. An athlete does not say, "Wait! I need to think about this next shot," when exchanging in a volley. They let it flow into being rather than try to calculate it in their brains. This is why those spectating believe these proficient performers are very intelligent. It seems like they are calculating so much in the moment (which they are), but it is not the same kind of calculation that brain intelligence comes from. The athletes, musicians, and artists do not view themselves

as being geniuses, because they are not calculating their performance with tons of numbers and statistics from their brains. They *feel* these numbers and statistics.

I do not want to demote calculations, as they can assist in making estimations. However, if we rely on a calculation for our total experience, it may not be the best route. What if we chose to wear a coat based on the time period of the year without actually feeling the temperature for ourselves? We may have to lug extra baggage around town, because our calculation said the experience would be a certain way. Now, we play the blame game with our calculators and everything surrounding the experience. This is the burden that can come with calculating without feeling.

In athletics, every time I thought about the shot before I took the shot, it always ended different than my expectation. But, when I went with the flow without the expectation, there was not any thinking, and I just hit the ball. I was "playing out of my mind."

Essentially, this is going in a particular direction by feeling with our hearts and owning that direction. In connecting with our hearts, we need to really feel into ourselves and our paths. "This feels right to me," is the simplest direction to go toward. This feels wrong to me, is the simplest direction to go away from. Easy enough, right?

Routine, predictable, anticipated, religious, traditional, and ritualistic practices can be something that keeps us

from following our heart's direction if we do not realize what purpose these rituals serve in our reality. Let's say we do the same ritualistic habit over and over again. There is no deviating from that routine. It is the same tradition repeated every day since it started. Where is the exploration? Where is the flow?

A simple personal example is exercise. There are many different ways to exercise our bodies, but when I get into a routine of doing the same exercise every single time, there is this dead feeling inside. I know in my head the program I am supposed to do, but I do not quite feel like I want to complete that program. This makes the exercise very difficult, because my heart feels like doing something else, but my programmed brain tells me, "No, you're not worthy unless you do this exercise like you've always done." I start comparing my current motivation with my previously higher motivation, creating a sense of frustration of, "Why not this time?" When I sink into my heart, I understand I am not supposed to exercise with this kind of motivation during this time. There is something else I need to do instead.

Motivational commercials promote the "just do it" and "winners never quit" attitude toward achieving something, which can be true to an extent. But, this was the attitude I had for the same exercise every time I went to the gym. Eventually, the exercises did not have the same "healthy benefits" like they used to, because I was not feeling in my heart what my brain was telling me.

It is perfectly fine to change the exercise however I feel like changing it, or not even working out at all. When I started going in this direction of my heart's feelings, I felt more whole and healthy. I was not dreading the routine and usual exercise. My heart did not quite want this rigidness and tradition at the time.

However, I cannot say always changing it up is the best either. Sometimes, my heart did not want the constant change. My heart felt like going back to the routine without deviating to something different. So, there was a conscious pursuit of this routine, ritual, and religion.

There is nothing wrong with going in either direction. It just becomes detrimental to our health when our hearts are in conflict with our brains. Our hearts being much more electromagnetically, intuitively, and spiritually powerful with energy may feel like changing, while our brain wants to stick with the program.

As mentioned when deciding to wear a coat outside, our programmed brains may calculate the year, month, day, and hour. Based on this calculation, we should or should not wear a coat. In this case, we are not considering the reality of the present moment, meaning we may have to deal with less than desirable circumstances. The easiest way to go about this decision is by feeling the present temperature and asking ourselves, "How do I want to experience this temperature." Then, own that decision.

The same can be found in our relationships with others. Are we staying around those who do not quite resonate in our hearts? Why do we not move into the space with others who do resonate with us? We are being torn between two states of staying with others no matter the difference in feelings or leaving them. Neither is *the* right answer. But, one is *our* answer and the answer we want to experience.

It hurts to leave someone or thing that has been there, but when things do not quite align, then it causes a very bumpy road, which can also hurt our health. Just look at a constantly conflicted couple. What does that feel like when continuing to be with each other, maybe for the reason that the man does not want to appear weak in the eyes of his peers, or the woman does not want to seem like she cannot provide the best experience for him? So, they continue this arduous relationship not to progress and grow through those conflicts, but to simply "beat a dead horse" through stubbornness, so to speak.

When we do not want to grow out of them, yet still continue to be in them, the relationship is heading down a path of death. Our hearts are not being fulfilled in the same way as they could be. We are not moving into that new space, which leaves that feeling lingering there until that energy kills us from the inside out.

Though, there can be a lot of health when going through conflicts with our partners. It is what allows us to move beyond those conflicting energies between us.

As mentioned, it is hard to only have one feeling of pursuit, because this reality is multidimensional. This is what makes the human condition so difficult. We can be pulled in more directions than just one. Creating these layers and dimensions of feelings can be hard to manage. Do we take this job but miss out on living where we grew up? Do we become more intimate with this person even though they had relations with our friend?

In these "bad" decisions, it may seem like we are off our divine plan and soul journey, but we are never truly off our bigger plan and soul journey. Those "unhealthy" deviations happened for a reason. We needed to experience that part of life just in the way it was experienced. That was the plan all along. We journey through such large energetic deviations that feel so stretched and dynamic in order to feel what that energy is like.

Usually, we do not actually know why we should go in a particular direction in life, but I feel like that is the connection to our bigger self. Tapping into that feeling is hard to do, because our brains can get in the way with all of the calculations between "this" and "that." As soon as we sift through all of the possible avenues, we are left without a decision. Following our intuition keeps it simple by just going with the flow no matter how blind the calculation. Whatever happens along that flow is what we should "blindly" experience.

Eventually, we come to realize an alignment with our core being and where we came from. Some of those decisions

might not be understood by ourselves and by others as to why staying or leaving felt right to us even after all these years, but it is just where we needed to go. Aligning ourselves is what allows for more flow into our greater being.

Intuition

Migrating animals like sea turtles, whales, or birds travel thousands of miles away from their home during particular times of the year. For humans, we have clocks, gages, and technology to do this for us, so we know when to turn and how far to go. But, do animals have these technologies?

What do you suppose is happening to those birds when they "feel" the urge to fly thousands of miles? There is no digital clock ticking away waiting to buzz the alarm, no gage telling them how far to fly, and no technology flying them there. It is intuition. There are energetic signals they felt with their senses to make an intuitive decision. Cats know when storms are brewing, because they can feel the electricity through their fur. Elephants know when tsunamis are coming, because they can feel the rumble of the earthquake through their feet and ears. Most humans are so out of touch with nature by the overuse of technology that we would never see a tsunami coming until it hit us in the face!

Essentially, these intuitive feelings come from our senses. But, if our senses are just like an old violin, dull and out

of tune, we will not be able to feel the music, let alone play in key.

What if we are told not to run? We lose the muscles in our legs and that ability to run. What do you suppose happens if someone tells us we are not supposed to hug other people because it would offend their personal zone? After a while, we lose touch of the intimacy and ability to hug.

So, we need to understand what we could be limiting ourselves from when talking about intuition from this particular perspective. In eliminating that limitation, barriers need to be broken by understanding what intuition is.

Intuition can be looked at simply as a judgment. "My intuition is *judging* something might happen." Is it absolutely correct every time? We are not perfect beings. We work from a limited state here in 3D. In this limited state, our judgments can only see so deep into life. Some judgments are more precise while others are less. Judgments and assumptions, seen as energy, has a duality within it; positive and negative. We see negative assumptions as passing judgment and see positive assumptions as giving compliments.

Now, how often does our society promote generalizations, profiling, and stereotyping? Not that often. Of course, if it is a positive judgment, no one seems to pay any offense, but when it is a negative one, watch out! We cannot avoid judgments no matter if it is a positive or negative one.

They nonetheless both come from the singularity that is judgment. Whether it is a good or bad judgment is up to us.

What if we recognized every single observation of this Universe and life within it comes from a place of judgment but did not hold the level of fear of negative ones and level of praise for the positives? How much would our intuition progress after this? We would not try to hold back our judgments the same way, because it is literally all we do!

If we try to completely avoid judging, then we restrict our intuition from the doorway into a greater understanding of life, because it was not nice to assume things about people. If I was not allowed to judge, then I could take this philosophy all the way to not assuming what color someone's shirt is because it would be offensive to anyone else who had a different perception of the shirt's color. Isn't this a little extreme? Most modern people would agree it is extreme, only because seeing a different color is not nearly as offensive. The color of a shirt does not have much spiritual weight in our lives.

This poses the question, "How much time and energy do we have to give in order to righteously judge something?" I could have a conversation with someone for an hour and assume some things about them they did not directly tell me. Why did I make those assumptions? Because, from my past experience and feelings, they basically told me without using words. Now, depending on how deep I was diving into their energy when making

this judgment, the threshold of offensiveness kicks in. People might say that after an hour of conversation, I am allowed to assume only particular things about them, but if I push toward something they do not approve of or want people to know, then they have a problem with it. They may feel like assuming that deeply into their energy requires a conversation longer than an hour. Maybe, we need to talk for days, months, or even years depending on the person.

At the same time, I am not trying to promote blurting out our deepest judgments of others, because we all have sensitive nerves running through our souls that still hurt if there is the slightest pressure on them. I have them, you do, and so does everyone else. Do I have their spiritual consent? If not, then this can be viewed as spiritual rape. I realize this is a harsh word to use, but I feel it is the truth. There is a different balance in everyone of how far into someone we are allowed to feel. Be sensitive to this threshold, but do not be afraid of it.

Keep our judgments in check by not crippling other people if our intuition goes to those depths, but do not feel restricted in letting our intuition go there. Let it run free while keeping it on a leash. The best way to do this is by realizing the stigmatic judgments can reach profound depths if we exercise them, but also keep the social agenda in mind.

Now, how do we know what we…know, and how do we not know what…we do not know? Where am I going with this? I do not know…But, bear with me.

Have you ever encountered a possible experience but had a bad feeling about it? What did you do? For most of us, those bad or weird feelings we get when going into situations are *known* feelings, and we understand where they most likely lead. "I have a feeling I have felt before in similar situations, and it is usually turned out this way." So, we understand what to do with that feeling because of our experience, intuition, and wisdom. The smaller and more common situations are obviously more understandable as to where they can lead. We have more control and insight into those experiences ahead.

I can feel when something is about to happen and what kind of experience it is going to be. Being in a living room, there are days (when I am more present) when I can feel within seconds that someone is going to come through the door, and (when I am really feeling it) will have a general sense of what they want. There are other times when I can feel what kind of conversation is going to happen, and even finish their sentences. This is not just with my friends but also with strangers.

It is not a psychic ability; it is just feeling into something around and within us. We all have this ability with something in life, but explaining it requires many details that takes too much time. So, "psychics" just say, "It's a psychic ability. I'll let you fill in the blanks." Life is a constant exchange

of energy, where we are always connected with everything. Being more in tune with something is our choice and can provide greater insight into that aspect of life.

We *do* know what others feel in the moment. Give ourselves more credit. Of course, this comes from a place of judgment, because who really *knows* exactly how someone feels? If someone has cried over a spilled glass of water and another has not, then does that mean they do not really understand that person's sadness? I am sure everyone has cried over something, so we all know what it feels like to be sad. It just may not be over the same things in life. Our wisdom comes in when we notice tears flowing down their face. We understand something negative happened in their life. And, we choose to go about consoling them in our wise way. Conversely, when someone is smiling, it is a good thing. We understand a smile means something positive happened in their life. Our wisdom kicked in telling us about this person's face. Where did that wisdom come from?

There are many other aspects to human conditions we are intuitive to, so who is to say we are not wise beings? Even dogs understand a smile from a frown on a human face did not lead to playtime. Why? They have experienced the feelings behind them. A frown did not lead to jumping and playful behavior, so the dog sees this correlation after enough experiences.

What is it like when we feel a certain feeling that is more ambiguous to us? We do not know what to do with it

other than recognize it is a feeling. Our intuition does not distinguish where it will lead to and will not. When and why is that? Could it be we simply do not have that sort of intuition just yet?

For example, most first jobs as teenagers are typically maintenance or service based work. Most of us did not enjoy those jobs, and we remember the feeling of applying for them, working them, and quitting them. Next time something like this job rolls around, we understand where it could lead and why. We choose to do something about it, but after progressing to more accountable and professional positions, there can be more ambiguity as to what could happen down the road. These are bigger feelings our intuition does not quite know what to do with. This is a newer situation at hand, which calls for newer intuitive feelings; thus, creating a different directional outcome in the Universe.

We can have the same feelings when in a relationship with another person. We understand when we are heading toward "flings" or when it is going to be serious. Though, we meet some people that give us a feeling we cannot pinpoint, and we do not know where it is headed, yet we continue into that mystery. It is a beautiful thing.

Could our intuition not see particular aspects of reality simply because we are so engulfed in that reality that we cannot see outside of it? Have you ever caught yourself feeling like the world needs more of something? I know I do, and I am sure we all see an issue in life that seems to

be missing its spiritual partner. "The world needs more community instead individuals. The world needs more art instead of business. The world needs more simplicity instead of complexity." These can be common feelings about the world and what it is missing. But, is that what it is *truly* missing? It might be quantifiable to some measurement, but how are we ever really supposed to know for sure the world is missing it? Our feeling about it is the way into that certainty.

Feeling like something is missing in the world means it is already there. That is what we feel; the anti-feeling.

So, is the world really missing it? Everything we can imagine is already here. We just have not chosen to see and feel it in life for our own particular reason.

The thing that separates the feeling of the world missing something is us paying attention to it. How often do we hear a sound, but it is like listening to gibberish or white noise? Why is that? If we do not have a big block of earwax in our ears, then it might be because it does not mean anything to us at the time. There is not much value we can see in retaining this particular noise.

At some point, we choose to see and feel that particular value and say, "Oh, that's what they were talking about all this time." If we do not feel into the words, then they stay as only words in our heads. In there, the wisdom is different than the wisdom in our hearts.

Where does our intuition come from? Where does the real power come from? That feeling comes from the gut, because that is right under our hearts. The electromagnetic field emanating around our bodies originates from our hearts. Our passions come from our hearts. Our expressions root deep inside our chests. The brain is simply a link in the chain and a piece of the puzzle to communicate what our hearts feel. We do not speak verbal words through our hearts, because our throats are muscles that speak. Our hearts are muscles that feel.

The feeling of something runs much deeper into the soul and in turn can also handle much more consciousness, but we like to conceptualize a lot of the world through books and philosophies (like this one). This is where hypocrisy comes into play; philosophies we like to believe we believe in, and behaviors we actually believe in. Reading and writing books can remain as concepts within our brains, but they will not be understood in our hearts until we have lived them in one way or another.

"Educating the mind without educating the heart is no education at all."—Aristotle

When reading a driver's manual about a car crash, we could be tested over the road conditions, type of car, and distractions that all played a role in the crash. We sit there thinking back on all those words describing what actually contributed to it. The test question reads, "What should the driver have done to avoid the crash?" Picture how long it takes to answer what conditions caused the crash and

what could have been done to avoid it. This could take at least a few minutes to think about, but that is just it; thinking about it.

Thought may travel fast, but feeling travels much faster. Feeling into the road conditions, type of car, and managing external distractions happens much faster. There is no real thought about what to do to avoid the crash or to even recognize the potential crash. We feel it coming and our feeling ignites in a nanosecond. That is not our brain at work. Our hearts felt what to do, because the decision needed to be done much faster. We cannot refer back to the manual for that sort of guidance. It takes personal experience and driving with our hearts.

We may not always be right, but that is the point of life. If it were always right, then what would we be doing here? It really just comes down to what we want in life and how we want it. Our intuition will let us know these things by guiding us to where we want to be. Our feelings may lean toward this opinion and perception in life, where we later realize it was not quite *the* point to life. So, we go in a different direction. Maybe it works better for us, and maybe it does not.

Trying to battle between what "is" and "is not" just creates a mind explosion that leaves us in a state of confusion. Follow our intuition and hearts, and our direction will be clear.

The Balance

"To be or not to be? That is the question," as Shakespeare famously said.

This is the most popular Western quote of duality I have ever heard. Which is it; white or black? Or, is it a little bit of both? Both sides need each other and have a little bit of each other within themselves. This is the balance between any duality, because we understand a greater aspect to duality in all its shapes and sizes.

We may understand people could want more or less of something, but it is only within the spectrum they wish to make it. And, there are also people who want much more and much less of that. This is really expanding our understanding of that particular duality and its size. The same concept can be viewed through any duality and at any scope. We do not have to limit ourselves to the normalcies of society in understanding these things about life.

What is the balance? What happens when we have sat down for too long? We eventually stand up. What

happens when we stand up for too long? We sit down. The same thing goes for any other duality in life. We live these extremes, where something comes and then it goes. We breathe in oxygen, and we breathe out carbon dioxide. We live a life, and we die a death. It is the fluctuation, oscillation, cycle, rotation, polarity, dynamics, and duality that is this Universe. We live in it. We experience it. We learn it.

Everyone wants something different at different times. Sometimes, we want a friend rather than a coach or a coach rather than a friend. It might be hard for the coach to be a friend and for the friend to be a coach.

Some people promote the positivity in life that says, "Life is a glass half full." And, other people promote the negativity in life that says, "Life is a glass covered in shit...I mean half empty." Which direction should we choose in life? We cannot enjoy eating a meal without eventually pooping it out at some point. That is reality. As much as we want to try, we cannot neglect the dynamic in the relationship. Why not embrace both sides of the relationship? Why is it all about the awesomeness that is the meal, but shame the evacuation of it?

Notice how Christianity and Buddhism are dualities of each other. I will generalize here, but that is another duality to cover; generality and specificity. Christianity generally favors pursuit and attachment to what we are doing. "If you love something, then fight for that love." Buddhism

generally favors stillness and detachment of what we are doing. "If you love something, then set that love free." There is a duality at play with the source of happiness and sadness. Christianity generally sees that sadness comes from not being as connected with what we love, and Buddhism generally sees that sadness comes from being too connected with what we love. One promotes, "I am incapable living without you." The other promotes the opposite, "I am capable of living without you." Which one is right and the point of life?

Is there a duality of the masculine and feminine archetypes? Most people seem to understand "boys will be boys" and "girls will be girls." But, what are the characteristics of those boys and girls? Generally, we know boys enjoy sports and girls enjoy fashion. Boys do not care about designing outfits and girls do not care about playing sports. Does this mean boys cannot care about what we wear and girls cannot care about playing sports? No, it is just the level of favoritism between the two. Sure, most boys care about fashion coordination, but it only goes as deep as putting on pants with a shirt. For girls, they may only care about being able to throw a ball up in the air. Notice how each aspect of life, how we look and how we function, are not delved into as deeply as they could by their opposites. Most boys cannot leave sports at just throwing a ball up in the air, and most girls cannot leave fashion at just putting on pants with a shirt. There are many more dimensions to sports just as there are many more dimensions to fashion that we choose to understand at a deeper level.

With this duality between the masculine and feminine, I pointed out a pretty common theme in Western society, but there are many others with deeper qualities in each side. I will just rip through a few I have seen recently and also throughout the ages. Please keep in mind, I am not saying men are *absolutely* this, and women are *absolutely* that. Nothing *has* to be the way it is. It simply seems like this is how things are going in today's world. These are generalizations that differ from each individual and relationship.

Men favor blowing things up, while women enjoy watching it grow. Men favor discomfort (exercise, pain, and etc...), while women favor comfort (relaxing, luxury, and etc...). Men want to compete and dominate, while women want to collaborate and heal. Men want to divide, while women unite. Men want to win women, while women want to be won. Men explain, while women listen. Men say, "Get over it," while women say, "Let it out." Men say, "I can do it myself," while women say, "I can't do it without you." Men enjoy the work ethic, while women enjoy the time together. Men favor professionalism, while women favor the arts. And, men favor intellect, just as women favor emotion.

With every duality, we live on one side more than the other, and we do not realize it, mainly because it is what we believe is *the* point of life. We believe it is how it should be done.

What is any fight about we get into with another? We felt like *this* was the right thing to do, and the other

felt like *that* was the right thing to do. Whose feeling was the right feeling? Well, both feelings were the right feeling…and also the wrong feeling, based on our state of consciousness. They were right to that person but wrong for the other.

It is us believing we need *this* more than the other needs *that.* "Why did you leave during this time of pain," the woman asks. He replies, "All I wanted to do was leave to collect myself." The man tries to convince the woman she needs to let him leave and figure it out on his own, and the woman tries to convince the man he needs to stay and work it out right now. So, they fight about what should have been the right behavior in the moment.

The grand question with balance is what causes the imbalance? It is egoic consciousness. Ego is consciousness. Consciousness is favoritism. Favoritism is our imbalance within a duality or dynamic. "I favor white more than black, evil more than good, feminine more than masculine, work more than family, organization more than destruction, death more than life, science more than religion, taking more than giving, unity more than division, and any other duality in any other preferential order."

The ego can only see a particular slice of life without seeing others. Try this out. Stand on one foot and focus on an immobile object. How much do you wobble? Now, close your eyes while still on one foot. How much do you wobble then? Why? Closing your eyes took away a

preferred sense of your consciousness; sight. Since there was not that attention of eyesight, there was an even greater wobble, because our egos favor eyesight for a means of balance.

As we lose more consciousness in any way, shape, or form, there is less perspective to pull from. Picture the last time you did some rigorous exercise. What was it like afterward? Were your hands shaking, vision blurry, or walking staggered? The overall feeling is clumsiness. Why? These are symptoms of imbalance.

The key point is seeing the imbalance was due to a lack of consciousness. We were not as present after the exercise as we were before. As we could not pay enough attention to our hands, they could not quite grab the glass we were going for. Our eyes become slower to search for a focal point. Not giving enough attention to our legs, we tripped over the crack in the sidewalk we normally would otherwise traverse. Essentially, the less we pay attention, there are more imbalances created that need tending to.

As the tightrope walker continues down the rope, every time they lose more balance than before, there was a lack of consciousness and presence during that moment, which requires just as much counterbalancing. The same goes with our lives and the dualities we live in.

Apply this to daily life not just with eyesight and exercise, but with our emotions, arts, hobbies, goals, relationships, and passions in life. There is no end to this balancing

act. It works with more than tightrope walkers or fitness fanatics. It is everywhere. The only limitation is ourselves by not seeing it in whatever aspect of life we so choose.

We know that in any duality there is a difference between two sides, but the two need each other in order to exist. Without the other, there is no conflict spinning around. It needs an egoic imbalance in order to create a pressure differential. It is like believing that only women bring children into the world. Conversely, men also bring children into the world. The masculine side comes together with the feminine side to produce an overlapping Unity seen as the Vesica Pisces. This is the child. Then, that child, either more masculine or feminine, intercourses with their opposite to continue the cycle. The process of singularity and duality keep intertwining, creating the vast scales of life.

The same goes with any duality. When we realize it always takes two to tango, then we ascend beyond that level of conflict and duality to see the singularity between them. We are ascending through the energetic states.

In the Unification of duality, there are the two polarities converging to create one; a family Trinity. The Holy Trinity; being, the Father, Son, and Holy Spirit needs to be rewritten. They are all the same thing but different aspects of each other. In my opinion, this Holy Trinity has been partially hijacked.

Why is it the Father, Son, and Holy Shit…where is the Woman? Why is this trinity missing the feminine? Right there, this perception of god is lopsided believing "he" is only male and masculine. A balanced way to describe this trinity would be, "the Masculine, Feminine, and Divine Unity."

A man realizes he would not be a man without a woman, and she would not be a woman without a man. White cannot be all colors at once unless it has its opposite; black. And, black cannot be absent of all colors unless it has its opposite; white. A spiritual lens to use when looking at this concept is blame. We could look at blaming the other person for a horrible experience without realizing any blame on our part. Or, we could only blame ourselves without realizing the blame in the other. Both are heavily favored creating a lopsided view of reality, but the unity and transcendence does not occur until the understanding that both were involved in the experience and need to be blamed for what happened.

In realizing the two parties of any duality need each other, there is an appreciation for the other. The hero might feel victorious in all his triumphs by beating down the villainous opponent. To their surprise, the hero will eventually see that without the villain, there would be no one to be named the hero. The hero would not have anyone to fight. The villain also needs to be recognized as an equal part in this battle between the two.

Do our enemies get this recognition and appreciation for showing us how we might not want to be? It is not often that

we feel this way toward the negative charge of the Universe. But, it keeps us in that battle. It is the battle that makes us feel alive, so when seeing we are equal parts in the battle and need each other in order for this conflict to continue, it can ruin the game and alter the entire energy of the game.

We then do not have the same sort of battle to engage in. Just like in the movies, where a massive battle between good and evil is dissolved, what do the characters do after that? Do they go to the grocery store, go back to their day jobs, watch the stock market, and so on? We, the viewers, just turn on another movie to feel another conflict, but in reality, we will initially feel lost after releasing the dualistic tension between us and them in any conflict.

The only way to get over that state of conflict is to fight about it, and then respect it. Fighting without respecting afterward just leaves the conflict spinning at that level cycling it back around, and the two will fight just the same as before.

Just look at any war. One is fighting for control and the other for freedom. How many times have we fought over the same issues throughout time? When are we going to learn we do not need war like we have it today? One is worried about the other shooting first, and the other is worried if they do not shoot first, then the other certainly will. What happens?

For the perception, "There needs to be war," with the intention there are bad people that need to die, those bad

people feel the same sort of disrespect for the other side. A nation feels disrespected when terrorists impose their forceful control, and terrorists feel disrespected when the other nation imposes their forceful control. Though, both sides of this conflict are coming from a perspective of love for their home and country. We do not view terrorists' pursuit as love for something, because we simply want to hate them and try to correct what we feel is "wrong" with them. And, terrorists also feel the exact same sort of motivation toward the opposing nation.

Dissolving conflict, there needs to be more respect for these perspectives in life. Believing that physically killing people or *winning* is the way to get over conflict only leaves the energy and conflict spinning within the Universe. It is stimulating to feel like we have surpassed the other in battle, but that still creates a high and low energetic pressure to sustain the cyclical spin. It will surely loop around later, and someone will incarnate into that role. If there is a victor within that duality and energy, then there will always be a villain somewhere to complete the circuit. "The only way out is in, and the only way in is out."

How do we gain that respect? It takes one to know one. Just imagine how understanding we are for drug addicts after we have been one? What is it like when someone is not a drug addict and meets another who is? One fights about how they do not need the drug, and the other fights about how they do need it. But, that level of conflict seems to dissipate once someone was not, became, and then was

not an addict anymore. There is no fight about right and wrong, because both sides of that energy were lived and are respected. They know what it is like to be and not be an addict. That is the price we pay in ending the conflict. There is no more feeling of right and wrong, seeing as both sides are equal and need each other. We cannot say we are better than the other since they actually helped make us.

Once we see this in the other, there is an understanding that releases this tension and imbalance, where there is more balance and harmony between the two. Just like a tornado arises because of high and low pressure from either side, it dissipates as soon as the two pressures battle it out and equalize. Humans can do the same by approaching the opposing side with a deeper respect of what they and the other are trying to do.

I cannot say the point of life is to search for balance in everything by increasing our consciousness and awareness at all times, because that is a heavy workload. Just imagine trying to be totally present without deviation from that focus. In our society, that is called a workaholic. When is the break and recovery? Some people can hold longer concentrations to achieve greater levels of consciousness within the moment, but is that the point; to be totally aware of everything at all times?

As children, we have incredible drive to learn, grow, and stay active. As adults, that drive dwindles into comfort, relaxation, and stagnation. This is the process of life and

death; consciousness is focused and released. Notice how there is a duality within consciousness. When we make expansion and progression "the all," we lose sight of contraction and relaxation. Everyone needs a break from something. The tightrope walker needed a break because their attention deviated from walking, which is why the imbalance occurred and they fell off. There is nothing wrong with that. Yes, we may have to do more work to get back to center, but we are human. We are learning.

In all this conflict, the objective view sees there is no such thing as right and wrong. It is all up to the viewer to define. Let's say the point of life is to have more money than before. Most people would agree that more money means more happiness. Otherwise, we would not feel the need to keep trying to get more money. We all have a threshold of what is too much money to survive, though. Even the poorest people in America live wealthier and more lavish lives than the majority of the human population. It just does not seem like it, because we are too desensitized to what that kind of poverty feels like. Interestingly, there are people who contrarily do not feel like trying to make more money. As mentioned, one needs the other to exist. People who do not feel like having as much money will give it to those who feel like having more money and vice versa. It is a constant exchange just like breathing in and out.

The actor and comedian, Jim Carrey, wisely stated, "I hope everybody could get rich and famous and will have

everything they ever dreamed of, so they will know that it is not the answer."

He is not saying earning money is a bad thing to do. He is saying that everything has its ups and downs. Gaining as much financial wealth is not *the* point of life that everyone *has* to pursue at *all* times. Not everyone wants to pay the price that comes with having various amounts of financial wealth. It is all up to the individual by how they view money and what they want to experience within it.

In another example, patience is a virtue, but based on what? What deems patience? Is it appearance of self-control? It can be seen as such, but is it? I have been told I am patient, because I do not seem to get flustered about issues going on around me as others might. Some may view this as patience. However, I have noticed within myself that my patience is credited to my impatience. I am so impatient that I desire to change directions more than grudgingly smash that obstacle head on. I am willing to attempt new possible solutions that may or may not lead to the original intention. This impatience and variable hast helps me feel more controlled within the moment, but it is because of my inability to stay with that particular original direction. Is my *patience* really patience?

There is no such thing as right or wrong. They all work in tandem with each other. It only depends on how our egos choose to view it and from what perspective. Is the Zebra white with black stripes or black with white stripes? The argument arises within our egos favoring more one side

than the other, believing that either the egg came before the chicken or the chicken before the egg.

With this, we all have a balance of our dualities. Not everyone feels the same balance as others. My balance for particular dualities in life would be an imbalance for another. In trying to find balance or the right fit for you, feel into yourself rather than following a model someone else programmed. The thing I had to do was try out their program but mold it to my own preference of balance to fit my own journey.

In learning any practice, I had to look at the programs others tried to tell me was "the way to do it" as suggestions rather than facts. They were only suggesting I try it out to see if it fits my personal style. When I looked at these suggestions as facts and they did not work out for me, I would have to go back to them for more "facts" to solve the issue. This philosophy created a bottleneck into becoming this other person in every "fact" they taught me. The real issue was that fact was actually not a fact and was a mere suggestion.

How do we gain this wisdom of what is our own balance, though? The tightrope walker illustrates this nicely. Walking on that suspended rope, the balancing act is what allows them to get from one point to another. If they favor a little more of one side too much to keep themselves upright, they counterbalance it. An important thing to keep in mind is there will always be a wiggle from one side or the other. Some wiggles are much greater than others,

which require just as much counterbalancing. But, in order to walk the line, there needs to be a general balance, and that balance is different for each person.

Each person has a different center of gravity and is walking on a different rope. Some ropes are extremely tight, while others can be very loose, each creating a different set of experiences in the journey. We all want to experience and feel different things in life. Though, we are all still walking.

Wisdom Within Us All

What is wisdom? We hear that word used in so many areas of life. People define it in various ways, claiming it is how many books we read, how many classes we sat in, how many years we lived, or how many experiences we had. Which is *true* wisdom? Is wisdom having the answers, or is it understanding we do not have the answers?

We are all made of the same stuff within this Universe, so what sets us apart? My dad once told me, "You're getting in your own way." Maybe, this is the very key. We do not give ourselves enough credit in our enlightenment.

We do need to understand that we have many answers as these incredible humans we are, but we should also understand we have more to question, experience, and learn. There is no age qualification in this one, and there is no time limit. Our souls are infinite. As understood in reincarnation, there is no beginning or end. Although, being in these physical bodies, they do seem to begin and end. What and why is that?

Our bodies are made up of the fabric of space that is the body of the Universe. Our souls pull that space into being, which creates our bodies. Essentially, our infinite selves feel the will to pull space into being to experience a finite human existence. This is growth and life. After a period of time, that flame withers, where our bodies scatter and dissolve back into space to be recycled as something else. This is decay and death. It is a continuous process for as long as we want to do it.

How long do we want to do this, though? How old is this Universe? Most Western scientists say it is 14 billion years old from the start of the most recent Big Bang. More radical spiritual explorers say it is actually trillions of years old, going through many Big Bang cycles similar to breathing in and out. Either way, it is a pretty long time! Now, a human's life is around 90 years, if we are lucky. Is this a little short compared to the rest of the Universe? The Universe has lived 14 billion to possibly trillions of years, while humans only live 90 years of that. Either, whoever created this did an awful job, or we do not see the bigger picture. There is so much to experience just in our human society over the last several thousand years, how are we possibly going to "get it right" in 90 years?

We have been reincarnating over and over again to experience this constant evolution and progression over time. We evolve life as we live, and we come back to do it some more. There is no finish line. We have been doing it for a long time on and as many planets, stars, and

galaxies. We experience being in relation to them and also being them as well. Our soulful wisdom and energy runs throughout our blood, genetics, and our entire bodies.

If our souls are infinite, then that means they are neither created nor destroyed. They were already there to begin with. Our bodies have taken the form they have taken through soulful manifestation of duality, energy, and light. Something we hear in religions is "becoming" beings of light; ascending to a place called Heaven, Zion, Shangri-la, nirvana, ecstasy, bliss, and so on. There are many names for this place of enlightenment and eternal light, but the myth of it is that we are already beings of light!

What do you suppose it is our eyes see when looking at another human? It is light. Light is vibration, oscillation, frequency, dynamics, duality, and energy. What do you suppose it is our ears hear when listening to someone? It is sound. Sound is vibration, resonance, logos, or The Word. "And, God speaketh The Word," meaning God spoke duality, vibration, and energy into existence. From that perspective, God did not have a mouth to verbally speak. God spoke energy. It constructed its body in the form of duality, vibration, and energy. It is all energy no matter what perspective and dimension we want to look at it.

With this realization, we are already beings of light like in the stories we have read throughout history. The difference between us and other beings is the kind of energy. Their bodies are vibrating differently than ours, and there are

many different vibrations, frequencies, and energies to experience.

Wisdom is understanding the duality, dynamic, and energy that is this Universe. Everything seems to be built on energy, and energy is fluctuation. A businessperson looking at the market does not feel on top of the world when the stocks shoot through the roof, and they do not feel like it has been destroyed when the stocks drop to the floor. Understanding the market fluctuations is the wisdom I am alluding to. It takes apprenticeship, knowledge, time, and participation. This businessperson sees the bigger picture within a smaller picture and a smaller one within a bigger one.

Something that contains our wisdom is realizing with every rise, there must be a fall. Working our way up to the top of any field just for it to be lost can be a devastating blow. When a scientist devotes their life to an incredibly demanding problem and that work is somehow destroyed, they will surely feel like there is no reason to go on. Just as we put so much energy into being with the ones we love, such great feelings of depression can overwhelm us when all that is lost. But, as something goes, another thing comes.

These fluctuations happen everywhere. Nothing in reality is permanent. They come and go just as we live and die. The dynamics of this Universe entails the notion that we are all creating miracles and also catastrophes at one level or another. It is a harsh realization, because we want to

believe we are good people with good intentions, but the inevitable difficulty and dynamic with that is we also do bad things within the very process of being good.

When mowing the lawn, destroying the entire existence of a spider community cannot be denied. We simply do not really care to acknowledge it. We have more important things to do than feel the guilt of killing a community of spiders, as they are all pests that are going to bite and kill every last human. Do we care to understand them on a human level? No, so we believe we are not doing wrong. But, when that same thing is done to the human community, it is a catastrophe. We, as humans, are physically and spiritually crushed.

Every time we walk on grass, we are essentially crimping each blade of grass in half. When we want to wear clothes, we need to strip cotton of their stalks. Eating carrots requires us to rip them from the Earth. If we want a table to eat them on, we need to chop a tree from the ground.

We are constantly destroying the communities around us while also building others. Sneezing flushes out the bacteria from our noses, teeth, and tongues. They had a home in there. When we urinate outside, we are causing a great flood on an ant hill community. Mother Earth hiccups, and gigantic tsunamis torrent coastal cities. People bite their nails, and millions of skin cells get shredded from each other. Sounds gloomy from any scope, but it is a part of life. Even Christianity's God (and many others) created a massive flood, because he did not

like the people in that area, but he did it out of the love he had for us. It is the same concept. Stars explode causing massive radiation pouring out toward the surrounding planets, but new stars are born.

The miracle to this enlightenment is life always recycles. There is nothing that cannot be reused in one form or another. Our cells come and go, berries come and go, our bodies, planets, and stars come and go. That is the dynamic of life. We no longer have to feel the same sort of guilt for destroying an ecosystem of life, because we want to build a house on their land, but we subsequently have to respect and realize it can be done to us if something else chooses. Mother Earth may want to rearrange her North American land through plate tectonics, and so we will be at the short end of this stick.

Just like the concept of food, we know so well what it is like to eat many other beings for our food supply. But, that one-sidedness has gone on for so long, we are absolutely horrified when it barely happens to us, like when mosquitos, spiders, alligators, or sharks bite us. We are just as much a part of life as anything else in this Universe, so we need to include ourselves in this relationship and exchange.

Is it interesting to see wisdom and understanding being shared with another? Where does that come from? We can empathize with others when we directly connect with what the other is going through.

Typically, people connect with what the other is going through, creating a sense of empathy and trust. "Don't feel bad about yourself. I've done the same thing in my life." The whole "been there" wisdom comes in, rather than only negatively judging their life decisions.

Imagine being able to see and do this with more aspects of life. How would our wisdom and relationships feel? This is what being "down to Earth" means. We are in touch with a balanced and also imbalanced reality. These energies can be hard to deal with in life, which is why we battle as much as we do. It is hard to see the full cycle of the fluctuations and energies on Earth, wherein we do not "know" where the battle might lead.

In our world today, we have so much division between so many dimensions of life. We have church separated from state, mainstream from underground, religion from science, countries from continents, borders between nations, and colors between races. This is not including daily divisions and exclusions we see at school, sports, neighborhoods, and the workplace.

Clubs, organizations, and institutions are forms of boundaries and limitations. There is a group of beings who follow a select culture and set of conditions. The conditions are specific to their habitat, being how they want to live and what they live in. Clearly, more particular conditions and boundaries create a smaller and less diverse population.

An environmental example would be wetlands; it is said to have the most diversity of life than any other habitat. A variety of conditions such as watersheds, grassland, and trees allow for more life to thrive. There is not as much discrimination in who can live there. Organizations might follow the opposite approach by making the conditions, or rules, policies, and religions, more and more particular, just like a desert. Life is not as suitable for a diverse population.

Look at the organizations in society creating these very specific regulations. It makes it harder for those members to invite strangers into their organization unless they first conform to the rules and policies. The downside to this concept is it hinders individual expression of differing beliefs. "Follow the program, or get out."

Obviously, not every culture (habitat) is fit to allow everyone to live there, but anyone can live anywhere if we understand these boundaries and conditions of the varying habitats. We would know how to live in any condition if the current residents allow us to give it a shot. We would not be scared out of the water by fish, shooed away from the trees by birds, and pushed out of the land by mammals if they are willing to work with us. There needs to be a certain kind of intention and trust coming from us, as well as felt by those already living there. If that is not there by both sides of this relationship, then it will not work nearly as long.

What does this discrimination do to our world and how we go about living? We believe it is completely acceptable

to fight the way we do and over the things we do. This is understandable considering where we came from, but are we not done with this? Of course, division is a necessary part of this Universe. But, equally so, unity is just as necessary. We miss out on working with the differences in the world from a more accepting demeanor. How often do we disagree with something but then try to convert them? Essentially, this is trying to take over their individuality to make them believe something else than what they want. It is like the Pac-Man game, where the gamer is trying to eat all the others. They keep trying to take over the next person. It is an "eat or be eaten" type of perception. The more they eat, the better off they are.

In marriage, most people would agree that a married couple might not see eye to eye on everything in the world, but do they try to constantly convert the other? Do they physically and verbally abuse the other? Hopefully not, but it does happen. Most of us would also agree that there are better ways to live within the marriage. So, this wisdom in marriage comes out; the two talk to each other, work with each other, and understand what each other wants in order to live a more harmonistic life.

Let's not leave that wisdom with just marriage. Let's see that wisdom all over humanity and life on this planet. I am sure Mother Earth does not appreciate all the fighting between us and would like a little bit more understanding of what goes into our desires of life. Maybe, we do not need to view this planet like it is ours for the taking,

simply because we are temporarily capable of it. We all live on this planet just as any other plant, animal, and ecosystem, so we can try to be a little more conscientious of our decisions, actions, and directions we are headed.

I used to believe those who did not see life the way I did were the "cancer." So, I believed about 80 to 90 percent of us were the cancer, when in reality, I was the cancer. I was trying to fight against others to get them on a particular pathway, but it was only making them dislike me and my message. The thing I had missed at the time was the willingness to work with differing people. Instead of trying to fight and beat them into my direction, we all have to work together and *want* to move this way. Otherwise, it creates dissonance between us and the cancer, where we are ripped apart destroying the place we live in.

In my opinion, we are growing up. We are not the same children we used to be. Our fights, arguments, and conflicts can be resolved between the two involved without a third party arbitrating their judgments.

Our society is gaining more wisdom through each life and generation we live, and we are gaining such wisdom for each of us. Simply being with the other and putting our hearts into the relationship in conflict is what helps us move into that space of friendship and understanding, rather than having a judge rule for us and keeping our distance from the other. It is harder to understand the conflict and where the other is coming from when we keep our distance.

Two athletes in dispute over whether the ball was in or out can be resolved by those involved without an all-ruling referee. The people of the nation do not always need a president to impose regulations in what is best for all of us. We know what is best for us and know how to express that with those who feel differently (unless they want them to). A married couple does not always need a counselor to tell them how to handle their fights, because at some point, the married couple gained that wisdom, realizing there is no absolute right and wrong. Everyone is different and feels differently about anything. So, the fight is individual and up to the two in the relationship. We just have to be willing to talk with the other in the relationship to see why there is and is not a real right and wrong between us.

Wisdom is seeing the value in everyone's opinion. How often do we listen to someone's viewpoint of life no matter the genre and feel like this person has no clue? I know I sure have, but I am starting to realize those people I believed were insane, stupid, neurotic, paranoid, oblivious, unconscious, and rude actually knew at the time something I did not. The hard part was getting over the perception they did not know something about life and I did. My ego could not handle that.

Once I had let go of that perception, I started listening more, and not just listening to the words going in one ear and out the other. I let those words stay in between my ears for a little bit longer than usual; sometimes for

What are We Doing Here?

We do have the belief and will power to create the world and life that we want, but we cannot have everything we may *think* we want. Our income might not be as much as we want, our weight might not as ideal, and life might not play out so perfectly. The point of life does not seem to *only* be manifesting our purpose. It is also accepting we cannot manifest or change everything about it. If we do not put our energy into changing it in one way or another, then we need to accept this is who we are at this point in our lives.

There are so many things to do and be in life, and it would be nearly impossible to take control over them all. Putting our energy and will power into our physical health might be something we wish would be different, but the reality is we feel like putting more conscious energy into something else, like being there for our friends, writing music, finishing college, or getting along with family.

Embodiment is living all kinds of egos and at different intensities. We live these dynamics, dualities, energies, and egos that is this Universe. Doing so, we *become* these

energies and egos. What is it like after a criminal finished their punitive time? At some point, they feel the need to do community service. They give their time and resources to others. But, they will run out if they do not eventually take anything from anyone.

Imagine only donating your money or food to those who do not have money or food. When will you get money and food for yourself? At some point, money and food need to be taken from another. And, it will also be taken from us. This is counterbalancing the imbalance they created. We all do it. If we have been extremely calculating and intellectual, then we will feel the need to balance it with moods and emotions. Both sides are still egoic and not any better than the other. It is only better for us at that time in our lives.

Getting over this battle between what is and is not ego simply requires the understanding it is all ego and at different intensities. There are people who rule over millions, if not billions of people. Some people rule over thousands, and others rule over hundreds. The intensity is much different, and their intent creates another aspect and dimension to these controlling egos. If we do not feel the need to do this in our lives, then we do not need to live this ego and energy at this intensity. The same goes with the servants being controlled. To be a master, it takes a servant. To be a servant, it takes a master. It is a necessary relationship in order for both sides to learn those intensities of ego. The king gives what the servants

want, and the servants give what the king wants. What does each other want, and what are they willing to do? That is what binds the two sides together.

Eventually, one side will not feel the need to go about the relationship in such a way just as the other will. There is not this relentless need to be loved by millions of people and also this relentless need for millions of people to love just one person. Things start flattening out instead of being so drastically stretched. The king will realize they are just as much a human as anyone else, and the servants will realize the king is just the same.

In order to truly grasp this, we need to have lived it at some point in life. But, when I say life, I am not talking about one life and one body. I am talking about multiple lives, as I explained earlier within reincarnation. These egos need to be lived at some point, but there are a good chunk of us in this life not living such drastic and extreme lives we read in history books or see in movies. There is a reason why these forms of entertainment are so stimulating. It is because the egos and energies of the characters are more extreme than normal life. The hero is always more determined than most people, the villain is more ruthless than we can imagine, the friend is more supportive, the rescuer is more athletic, the damsel is more passionate, and the storyline seems to create such a coincidental scenario that it blows our minds as to how it could possibly happen in real life. These characters and their egos are what we look for in the movies, because we

do not experience them at the same intensity in real life. Maybe, a part of us misses feeling them in our past lives. Maybe, we had these capabilities in another reality that we do not get to experience in this one, such that we enjoy seeing them on the big screen instead.

This epiphany or enlightenment is the embodiment of that dynamic, duality, energy, and ego. We realize, "Wow, I've felt the ego of being a great ruler and also an obedient citizen." The big difference is how we go about this relationship.

So, when we do want something from another person or thing, how do we approach it? How are we going about it? That is the key; how do we go about these relationships, dualities, and egos? Embodying our past experiences in how we went about our relationships and the dynamics between us, we then understand those feelings within our hearts, which is where our deep wisdom goes.

Being more transparent and open about my intentions creates more understanding within my relationships. If I let others know my deeper intentions and they let me know theirs, we both have a better understanding of the relationship and experience. If my intention does not quite align with the other's intention, then understand to not continue connecting. But, if we both understand, we want something from each other, then we understand each other, and the relationship is much more in resonance.

Keeping our intentions hidden can create a very rocky relationship with trust issues. What if an engaged couple did not reveal their deeper intentions of the relationship to each other before the wedding? They had not told each other that is what they wanted from the other, so the entire time, they had energetic trust issues, because they had not been honest, open, and especially accepting about why they are with the other. There will be fights about it since there is this underlying intention not yet revealed, and it will not dissipate until they talk to each other and work through this energy.

Dissipating these energies takes an understanding of what they feel like and also a little bit of exploration into the unknown aspect of unifying them. Embodying these levels of ego is what we have been doing for lifetimes. We went about our relationships in particular ways, which created certain experiences that eventually taught us lessons. With this wisdom and experience, we can go about our relationships from a much deeper, understanding, and willful way. We just need to understand what is going on in any relationship in our lives. Then, that experiential embodiment and wisdom can now surface to be emanated.

Our embodiment helps us to be able to pull from any of these experiences and levels of ego. If we are faced with someone charging after us, we may feel the need to pull on a particular ego at a particular intensity if we feel it is necessary. We may feel the need to pull on a particular ego at a particular intensity. One ego might be a great warrior

pushing through the pain of confronting an enraged rebel. Another ego might be a runner sprinting away long distance like the ancient messengers. What if we wanted to emanate the motivational speaker influencing someone to stop fighting? What if we wanted to emanate a supportive mother empathizing with another's emotional issue? There are so many egos we can pull from after having lived through them.

I am not trying to promote to go out and play the "do and be everything" bit some people choose to do (and, myself at one time).

"You can be anything, but you can't be everything."
—Monique Marvez

She is saying our focus is what gets us somewhere in life. We want to be something, then pull in that focus to make it a reality.

When looking at different aspects of life, we tend to pick and choose which ones are respectable; which ones get credit where it is due. For most, it is a pick and choose game, because we define success through a limited lens. "How could they possibly waste their time and energy doing that? They aren't successful unless they've been able to do *this* over here. *That* over there doesn't quite matter as much." This definition creates a bubble of misunderstanding we live by encapsulating us.

The downside is we can segregate the two and create a hierarchy or grading system. *That* is what makes us feel like a failure, and we do not respect *that*. The upside to this definition of success is it makes us feel proud when we achieve what we defined as success. We reached our finish line, because we actually did *this* rather than *that*.

Other examples of success can include jobs, revenue, expenditures, fashion, food, artistry, socialization, and on to infinity. We all create them by believing *this* is it, while *that* is not. This definition and bubble is what determines our happiness and sadness; happy when we achieve it, and sad when do not. We have created a definition of success such that it is so hard to see outside of it until we pop the bubble.

When I learned any practice, I created definitions that made me believe what was a success or a failure. In athletics, I believed a certain amount of mobility determined skill level. If they did not show my standard of agility, I disrespected their ability to play the sport. In music, I believed a certain amount of structure and coherence revealed a successful musician. If they did not show that standard of structure and consistency, I disrespected their expression by believing they were a failure.

With this disrespect, there was not an understanding of why they did what they did, and what they got out of it. I was disconnecting myself from that aspect and energy of life, which meant I could not *be* that energy. When I thought mobility was the definition of athletics, I could not embody strategy and conservation. When I thought

structure was the point in music, I could not embody improvisation and flow.

There are so many more to mention and on so many other levels, so I will let you see and feel them. But, as I did not want to admit and show respect for another's direction in life, it was that much more difficult to understand and be it myself. My ability in athletics was missing those pieces of strategy and conservation I needed in order to play a more complete game. So, I could not expand my practice by however much I could not be that energy I hated to admit.

However, the more I admitted and respected that aspect of life, I started becoming that as well. It was a part of me, now. I expanded myself in ways I had never imagined. My embodiment of those energies in the world reached greater depths.

I am not saying we should not create definitions of success, because of its pathway to divisions and boundaries. Success is the drive to get somewhere in life. It is a pretty simple approach.

The point I want to make with this is depending on how much we attach ourselves to this drive without realizing the differences in life, we might forget the respect these differences deserve when interacting with them. If someone defines driving a fancy car and wearing a three-piece suit at a multi-million dollar corporation as being successful, then they may disrespect the homeless man sleeping on the street corner of their office. How would

they view them? "Ugh, such worthlessness. They should be disposed of." And, we continue to live in this segregated community with that energetic intensity attached to it.

If we want to expand ourselves and to understand the vastness of the Universe while still wearing a three-piece suit at a multi-million dollar corporation, we need to understand everyone has a different definition of success and failure in life. We all have that right to determine what that definition is and choose to live in that bubble. I apologize if this is popping anyone's bubble, because we can even feel success in the belief that we have "no bubble" to pop!

Respecting the direction of others in life is all we can do. We do not have to do what others are doing, but we can still respect what they are trying to experience in life just as what we are trying to experience. True empathy comes in this respect to really understand what they wish to experience. It takes energy on our part to really feel into and respect their direction.

I know it can be hard to work with other people who want to express themselves and their opinions in ways that upset us, but we are not all in exactly the same place of our journeys through this Universe. Expressing our authentic self does not have to *only* be letting others express themselves how they want, because it is also about our expression as well.

We can pick and choose our battles and harmonies. For some people and areas of society, I have issues with how

people express themselves. Other areas, however, there is not that same sort of frustration. That is my favoritism, preference, and ego coming out. I appreciate my ego, just as I appreciate the ego of others.

As a child, I was handed particular rulebooks throughout many different social programs; academia, athletics, government, religion, and even spirituality to name a few of the big ones. Of course, they are trying to create a communal philosophy to live by in which we can all be comfortably happy, but not everyone is the same as everybody else, and creating a rulebook for everybody can funnel us into being robots following the same program. How can I be me if I am constantly following someone else's rules?

Trying to be my "authentic me" had me in circles figuring out what was and was not me. That was the very thing causing my cyclical frustration spinning round and round; trying to find me somewhere else but within me!

What is being our true authentic self? Is it doing *this* and not *that*? Is it trying to be as good as we can be instead of being anything bad? Is it trying to save every life and not kill any life? I have been trying to really understand what being my authentic self really means, especially in a time when there have been so many rules to obey.

What I have come to realize at this point in my life is that being our authentic self does not have to be following a rulebook unless we want to follow the rulebook. It is not about only saying yes to everything, and it is not

about only saying no either. We cannot always be the agreeable Saint, and we cannot always be the controversial Demon. Being authentic is understanding when we agree or disagree, and what feels right or wrong, what we feel the urge to do in the moment. We have two options; going toward or away from this point in life.

That is what gravity is; the most common thing in this Universe. It is everywhere pushing and pulling on everything. It is friendship. It is the love we see when someone looks at another and feels it in their hearts. It is that feeling of care and compassion we feel in family and close friends. That is what holds friends together on Earth and what holds stars and atoms together in space.

It is a beautiful thing, which is what a relationship is at any Universal scale; our choice to engage or not. We love Mother Earth, and she loves us, so there is a strong gravitational force. We can have gravitational forces for practices and art forms, friends, family, and nature. What about the gravity pulling someone's attention toward a book, song, field of study, or star-gazing in the night sky? Gravity does not have to only pull on our physical essence. It can run deeply into more invisible ones, too.

Though, when we do not love something, we repel away from it. This is detachment. Life is essentially about attaching and detaching of various things in this Universe. I have an attachment to my body. I love it enough to not let the atoms fly out in every direction. Essentially, my

attached essence keeps the relationship intact, and when I die, my detached essence lets it fall apart.

Seeing how we create gravity based on our authentic being can be very powerful in how we go about our lives. Embrace and understand what we feel to be right and wrong for us. Understand that to be different for each person. Understand that we do not understand! This level of self-awareness is so empowering.

Although, a misconception in conflicts and duality is one I fell into by believing in a drama free world. No two things are alike, which means conflict will always happen at some level. Conflict is everywhere, which also means drama is everywhere.

But, it is ok to have drama in our lives. It is what gets us through our issues. When was the last time we worked through a conflict without drama? Was it a very unemotional way to go about our differences? Conflict, difference, dynamics, duality, and energy is what this Universe is made of. There is no avoiding conflict in life; if we want to live, then we need to kill another for their life. It is inevitable in this reality.

Shining our authentic self means knowing who we are from our core and standing up for what we want to experience in the world. Not everyone is always going to agree with that or how we choose to go about it, but no one is perfect, yet we are perfect just the way we are. This is the disgustingly beautiful dynamic that is life...

Summary

In all, I hope there is something to take away from this. We all seem to live a different set of circumstances in life, being that we are all living a truly unique life accumulating in this wondrous place we call the Universe. It is truly a beautiful place to live in, experiencing all of these different forms and dimensions of energy.

My hope with this book is to show people that we can experience life in more ways than just the normalcies we have been raised with. There is incredible depth we have yet to get back in touch with. Getting closer and more in touch with our hearts allows us to feel where we came from, what we are doing, and where we are going without judgment of "right" and "wrong." It is what we need to experience and feel so we can learn right from wrong, and wrong from right.

We can now flow through life like water down a river. The flow *just* happens. There is no program the water needs to follow. It is ever evolving...

"Be water, my friend."—Bruce Lee

Gratitude

Thank you all for helping me through this process. The timing was a very interesting one, and many have been there just at the right time.

I want to thank my Father for being there to support me through my journey. You put in a lot of work to provide me with more resources than I could ask for. I am learning through example in being a greater man. Thank you, dad.

I want to thank my Mother for understanding what I am going through during these times. You provide such a space for me to explore myself and my surroundings. You are a nurturing woman. Thank you, mom.

I want to thank my sisters for putting up with my brash delivery and neediness to express myself. Even though we do not always agree, you still answer a call. That is family. Thank you, sis's.

I want to thank my friends for doing just the same. You deal with my transitions and still stuck with me. Even though you are not blood, there is still that bond. Thank you, friends.

Lastly, I want to thank strangers for giving another stranger an opportunity. For the people I did not know but grew to know, you knew nothing about me, yet for some reason you continued. "All friends were once strangers." Thank you, strangers.

Cannot say it enough, thank you all for doing what you do!

Printed in the United States
By Bookmasters